IMAGES
of America

PAXTON

ON THE COVER: The Sons of Paxton baseball team was one of the many activities of this energetic organization, which formed in 1922 for all men over 18. At that time, George Whitney offered the free use of a room in his blacksmith shop for a year. His wife, Juliette Whitney, added the stipulations that the men needed to keep it clean and promise not to gamble or play cards on Sundays. The Sons of Paxton held meetings in the town hall until 1927, when they began construction on their own clubhouse. Pictured here are, from left to right, (first row) mascot Danny Woodbury; (second row) Walter Hughes, SS; Wesley Ferry, IF; Archie Hughes, 2B; Samuel Knipe, captain and CF; George Maccabee, CF; and Robert Catherwood, RF; (third row) Daniel Woodbury, manager; Lawrence Girouard, 3B; George Bradshaw, P; Gaylord Pike, 1B; Walter Pike; and Richard Catherwood, official scorer. (Courtesy of the Paxton Historical Commission.)

IMAGES
of America

PAXTON

Dr. Barbara A. Beall

ARCADIA
PUBLISHING

Published by Arcadia Publishing
Charleston, South Carolina

Printed in the United States of America

Library of Congress Control Number: 2012954720

For all general information, please contact Arcadia Publishing:
Telephone 843-853-2070
Fax 843-853-0044
E-mail sales@arcadiapublishing.com
For customer service and orders:
Toll-Free 1-888-313-2665

Visit us on the Internet at www.arcadiapublishing.com

*This book is dedicated to the past and present residents of Paxton
and to the coming generations who will guide its future.*

CONTENTS

Acknowledgments 6

Introduction 7

1. The Common 11

2. Town Government and the Church 23

3. Agriculture, Commerce, and Industry 35

4. A Commitment to Education 57

5. People and Places 67

6. Celebrating, Serving, and Playing 91

7. Moore State Park and Land Preservation 117

Bibliography 127

Acknowledgments

This book celebrates the 250th anniversary of the incorporation of the town of Paxton, on February 12, 1765, and thanks are due to many people, past and present, who have made this project possible. The Paxton Historical Commission had the initial idea for the book, and I sincerely thank members Sue Corcoran, Anita Fenton (chair), Richard Fenton, Donna Odorski-MacLean, Larry Spongberg, and Pam Stone Hair for the invitation to author this text and for sharing their knowledge, expertise, and humor.

The process of researching, writing, editing and compiling the text and images was an extended one. Anita and Richard Fenton were always available for consultation and editing, and Richard also scanned the images and climbed up the church steeple to photograph the bell from the Revere Copper Company. Larry Spongberg guided me through the collections at the Paxton Historical Commission with insight and patience, sharing his professional expertise and the personal experiences of his multigenerational roots in town.

We are indebted to Edward Duane of the Paxton Historical Commission, who laid much of the groundwork from which we have all benefitted. Unless otherwise noted, all images appear courtesy of the Paxton Historical Commission.

Hon. Ledyard Bill and Roxa Howard Bush made substantial contributions in recording the history of Paxton. Special thanks go to Denis Melican, who served as the superintendent of Moore State Park and as a "guardian" of its history. Thanks to my editor, Katie McAlpin, and to Katherine and Laura Taronas, who published Then & Now: *Paxton* with Arcadia Publishing.

We are fortunate to have had support from Assumption College, especially the d'Alzon Library; Jacqueline Chlapowski and Mary Wood Mudge; the Richards Memorial Library, with director Debbie Bailey and her staff; helpful town employees; Rev. Don Whitcomb of the First Congregational Church; and Anna Maria College. Last, but not least, thanks to the Crouch and Wentworth families and all the other "heroes of history" who have donated photographs and materials to the Paxton Historical Commission.

My gratitude goes to my husband, Dr. Mustapha S. Fofana, for his encouragement, and I want to thank the residents of Paxton, who have welcomed us with such warmth.

INTRODUCTION

Like a patchwork quilt, Paxton was originally pieced together from lands of the neighboring towns of Leicester and Rutland, and, later, in 1804 and in 1838, from the town of Holden. High in the hills of central Massachusetts, the elevation ranges from approximately 900 feet above sea level to almost 1,400 feet on Asnebumskit Hill. Approximately 50 miles west of Boston and sharing a northwestern border with Worcester, Paxton lies near the geographic center of the Commonwealth of Massachusetts.

After several unsuccessful petitions to the court in Boston, Paxton was incorporated on February 12, 1765. Fueling the determination of the area residents to form their own town was the difficulty of having to travel great distances to attend public worship.

Early settlers in central Massachusetts displaced the indigenous Native Americans, the Nipmucs. The translation of this name means "the fresh water people," which is an apt description because the land in Paxton where they hunted and fished has four streams flowing into three drainage areas. This area was ideal for human and animals alike, as evidenced by a series of trails and temporary settlements, particularly near Turkey Hill Brook and Asnebumskit Hill.

Moving westward from the coast, European settlers claimed land in central Massachusetts for permanent agricultural settlements, bringing with them a radically different concept of individual property rights. Early settlement was sporadic due to a series of wars and skirmishes between major claimants such as Britain, France, and Spain, which pulled all local inhabitants, including the Native Americans, into the struggles. The largest neighboring town, now called Worcester, was abandoned several times. In 1713, at the close of the Queen Anne War, Jonas Rice (1673–1753) and others resettled Worcester, signaling a permanent change in the control and ownership of land that would soon extend west to Paxton.

Many early settlers remembered the raid on Deerfield, in northeastern Massachusetts, in February 1704, when the town was burned and 56 villagers died. Several survivors marched as captives to Canada, and one, Rev. John Williams, wrote a book of his family's experience, entitled *The Redeemed Captive*. First published in 1707, it remained popular reading for decades, with subsequent editions published in 1758 and 1863. The book presented a poignant tale of the village attack, the fatalities, the hard winter march, and the eventual return of many captives with one glaring exception: one of the reverend's daughters, who married a Mohawk man and refused to return.

Documentation of European settlements in Paxton begins in the 1740s, with agriculture and several supporting commercial ventures such as gristmills and sawmills. These mills were centered in the area of what is now Moore State Park, where the 90-foot drop of Turkey Hill Brook provided necessary waterpower. February 1765 marked not only the incorporation of the town, but also the degree of security the settlers now had in creating an expanded, permanent settlement and investing in its future development.

Soon after incorporation, in April 1765, Paxton residents voted to build a central meetinghouse on land given to the town by Seth Snow. It was constructed in 1766 and initially functioned as

both a religious and a municipal center. The term meetinghouse was derived from the Puritans' belief that no human structure could be worthy of being called a church. The New England meetinghouse housed both religious worship and town business, maintaining this duality into the 1800s.

The new town was named in honor of Charles Paxton (1707/1708–1788), who was born in Boston. According to *The History of Paxton*, written by Hon. Ledyard Bill, a former state senator and town selectman, and published in 1889, the name of the town was decided when the House of Representatives passed the bill for incorporation. Because there was no town name designated on the document, the council decided on Paxton to honor Charles Paxton, the marshal of the admiralty court and a favorite of Massachusetts governor Francis Bernard and deputy governor Thomas Hutchinson. Reportedly, residents initially accepted the town name because of Paxton's assurances that he would procure a bell for the meetinghouse.

By 1766, Charles Paxton had fled to Britain to escape an angry mob that was chasing him because he allegedly searched a warehouse without the necessary warrant. He returned, but then became embroiled in escalating Colonial tensions centering on the series of oppressive acts by the British government, including the Stamp, Sugar, Quartering, Declaratory, and Townshend Acts. Given his role and responsibilities, he would have been continually required to enforce these unpopular taxes levied on the colonists. He ardently called for a British military presence, thereby heralding future hostilities. After approving the seizure of cargo on a ship belonging to John Hancock, Charles Paxton was hung in effigy from the famous Liberty Tree in Boston. By 1776, he was banished from Boston and again fled to England, where he remained for the rest of his life. Given his role in the tumultuous events culminating in the America Revolution, it is not surprising that his promised gift of a bell to the town never materialized.

Despite several later attempts by residents to change the name of the town, Charles Paxton's legacy continues to this day, directly contrasting with the active contributions made by townspeople to the cause of the American Revolution. As tensions increased, particularly after the Stamp Act of 1765, which levied a tax on all printed papers, such as legal documents, newspapers, and licenses, it is easy to imagine how communities and even families held divided loyalties. The town of Paxton was no exception, and the well-respected Earl family split along generational lines. While Capt. Ralph Earl served in the Continental army, two of his sons, Ralph Earl (1751–1801) and James Earl (1761–1796), left for England.

The complexity of the tensions and loyalties surrounding the revolution is evident. The Earl brothers were able to acquire artistic training and experience with another American artist, Benjamin West (1738–1820), who had gone to England in 1759. By 1772, West was the history painter for King George III. Interestingly, prior to leaving for England, Ralph Earl provided drawings that served as the models for a famous series of four engravings of the Battles of Lexington and Concord by Amos Doolittle. Earl first drew the actual landscapes and then filled in the people and events based on eyewitness reports. Ironically, these engravings served as visual records that continued to justify the revolution, even while Earl continued his training in England. The Earl brothers excelled at portraiture and landscapes, and they eventually returned after the revolution, James to South Carolina and Ralph to Connecticut.

Their father, Capt. Ralph Earl, remained a prominent town resident, serving in the Continental army alongside other townsmen, including Maj. Willard Moore. A total of 33 local men were drafted as minutemen, and many enlisted in the Continental army. At the Battle of Bunker Hill on June 17, 1776, the group joined Col. Ephraim Doolittle's Massachusetts Regiment. Maj. Willard Moore died in that battle and is memorialized with the naming of Moore Memorial State Park in Paxton. In *The History of Paxton*, Hon. Ledyard Bill states that under the command of Capt. Ralph Earl, the standing company "did valiant service, and bore their fair share of the hardships of the long campaign for liberty and independence."

Tensions continued after the revolution, but they were now between the new colonial government and its own citizens, many of them veterans, who suffered from postwar economic strains, a credit squeeze with aggressive tax and debt collection, and a lack of hard currency. Many demanded to

be reimbursed for supplies requisitioned during the war. The Shays' Rebellion, led by Daniel Shays, drew its main support from central and western Massachusetts and included several Paxton men, who joined the march to Worcester in support of this cause. A final resolution came only after the death of several "Shaysites." There is scholarly support that this rebellion strengthened the resolve to abandon the weaker Articles of Confederation in favor of the US Constitution in 1789.

From the 1790s through the 1800s, Paxton experienced times of optimism and growth as well as a period of economic decline and a population decrease. Evidence of the growth is seen in the concentration of numerous Federal-style homes, the expansion of civic organizations, and the establishment of a thriving shoe and boot industry in town. This local industry grew to meet the demands, especially for a type of ankle-high, heavy shoe called a brogan, which was wanted by several groups, including slaves in the South, soldiers in the Union army, and settlers moving west.

However, the boot-making industry collapsed after the end of the Civil War because of the loss of government contracts and the official end of slavery. A fire in 1873 destroyed the largest surviving boot factory, finalizing the end of the booming boot trade. With this economic reversal, the population of the town dropped precipitously, from almost 900 in 1870 to 561, as reported in the 1890 *Gazetteer of the State of Massachusetts*. The *Gazetteer* also recorded that the town had two wooden box factories, one carriage factory, 31 men who made boots and shoes, and 135 farms at the time.

At the end of the 1800s, the town entered a new phase, becoming a retreat for many residents of the increasingly crowded and industrialized cities. Drawn by the tranquil, rural nature of the town and its location in the hills of central Massachusetts, summer people came to the several inns and hotels in town, such as the Summit House, the Asnebumskit House, and the Kenilworth Hotel. Transportation was by stagecoach for a time, and the Worcester-Paxton route was a popular one in warmer weather. Later, there was service from the Worcester Consolidated Street Railway, which came from the West Tatnuck area of Worcester, just four miles from Paxton center. This system was discontinued in 1945 and eventually replaced by buses.

In 1888, the town voted to construct a separate town hall, following the growing trend of physically separating the offices and meeting places for activities of church and activities of state. Hon. Ledyard Bill, a state senator and town selectman and the author of *The History of Paxton*, donated the land to the town, and $1,500 from the estate of Simon Allen supplemented the costs of construction. This signaled a major shift in the relationship between church and state. The original meetinghouse, constructed in 1766, had been the home of religious worship and town governance, a common practice in Massachusetts. In fact, since the 1630s, there was a statute requiring membership in the Congregational church if one wanted to vote. Following the dissolution of this close tie, the Paxton Congregational Church was moved from the town common to a site nearby, although the town government still operated from the building. With the eventual construction of the new town hall, there was adequate space for a large meeting hall, a kitchen, the library established by Hon. Ledyard Bill, and the select board office. The offices of the town clerk and others were operated out of their respective homes until the mid-1900s.

In 1897, a town warrant was approved for the consolidation of the five original local schools into a new, larger central school, which opened in 1900 near the town common. Discussions continued regarding a suitable library, and in 1926, the Richards Memorial Library opened thanks to the philanthropy of Ellis Richards.

Throughout its history and despite its proximity to Worcester, Paxton has maintained its character as primarily a farming community while simultaneously transitioning into a suburban bedroom community in the 1900s. In 1915, the population was 471. By 1940, it had grown to 791, with approximately 35 percent of the population considered rural, with dairying and market gardening as the chief agricultural occupations as well as some blacksmithing and sawing. Population pressures impacted the town after World War II, as evidenced by the nearly fourfold increase in population between 1950 and 1970. The major employers in town shifted to the town government and Anna Maria College.

Parallel with the birth of the baby boomer generation from the mid-1940s to the mid-1960s and the increased building of homes was a growing awareness of the necessity for land conservation. Charles Boynton bequeathed Boynton Park to the people of Paxton and Worcester. Large tracts of land bordering Asnebumskit Hill have been preserved for the protection of Paxton's water supply while Worcester-owned reservoirs and contributory streams are no longer accessible to the public. The Massachusetts Division of Fish and Game established the 262-acre Moose Hill Wildlife Management Area, and the Massachusetts Department of Conservation and Recreation purchased the land that is now Moore State Park, which currently encompasses approximately 725 acres. Most recently, a collaboration between the commonwealth, Worcester, Paxton, the Paxton Conservation Commission, and the Greater Worcester Land Trust has protected the watershed of Southwick Pond and purchased more than 56 acres at Muir Meadows in Paxton.

Despite the fiscal challenges facing the town, which are largely due to broader economic factors, Paxton continues to maintain its commitment to the well-being of its residents, its religious and civic responsibilities, and the importance of education and cultural activities. These elements have all been highly valued since the town's incorporation in 1765, and participation in town government remains a significant part of town life, with open town meetings still held in the New England tradition. The town of Paxton celebrates its 250th anniversary on February 12, 2015, and a yearlong series of events is planned, including the ringing of its Revere bell from the foundry established by the patriot of the American Revolution, Paul Revere.

One

THE COMMON

The central common area, or town green, is a quintessential component of early New England towns. Situated at the apex of the long hill from Worcester, the Paxton common commands an important site at the confluence of the southeast-northwest road (now Route 122, or Pleasant Street) and the north-south road (Route 31, or West Street). After the town was incorporated on February 12, 1765, the residents soon voted to build a meetinghouse that would serve religious and civic functions. The original building was constructed on a former cow pasture donated by Seth Snow. The meetinghouse, now the First Congregational Church, was moved in 1835 to its present location, leaving the original town common as open space.

The common was and still is the center of town life. Important buildings housing major religious and civic functions and integral activities of town life encircle the common. These currently include the First Congregational Church, the early town cemetery, the town hall, St. Columba's Catholic Church and rectory, and a number of monuments dedicated to Paxton natives who have died in war.

A couple of hundred feet away, on West Street, stands the John Bauer Senior Center, also called the White Building. This was once the central school for the town, but it now houses the Council on Aging, the Paxton Historical Commission, and meeting rooms for the community. Adjacent to the White Building is the newer Paxton Center School, which serves students from kindergarten through eighth grade. In addition, numerous homes dating to the 1700s and early 1800s are near the common and line the roads to and from town.

Over time, several buildings have been moved, while others have been lost to fire or purposely razed. More recent additions include the Richards Memorial Library, several shops, and two banks. Farther east on the road to Worcester (Route 122) is the 2010 Paxton Safety Complex, housing the police, EMS, and fire departments for the town.

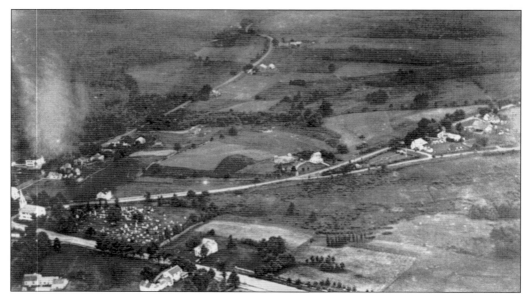

The early aerial photograph above shows the northwest quadrant of Paxton, with the First Congregational Church in the lower left. The town center is at the confluence of the major roads linking Paxton to Worcester to the east, Rutland to the west, Holden to the north, and Leicester to the south. The later aerial photograph below was taken in 1990 during the 225th anniversary celebration of the incorporation of Paxton. The substantial structure in front of the church is the town hall, with West Street running alongside the building.

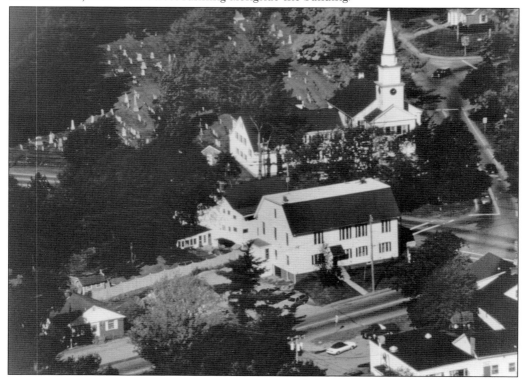

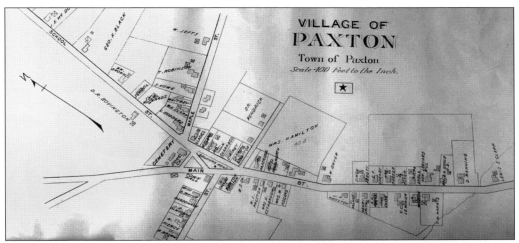

This map shows the town of Paxton in 1898. What are now Pleasant Street and Richards Avenue are labeled as Main Street and School Street, respectively. The First Congregational Church is seen here in its present location, having been moved from the town common in 1835.

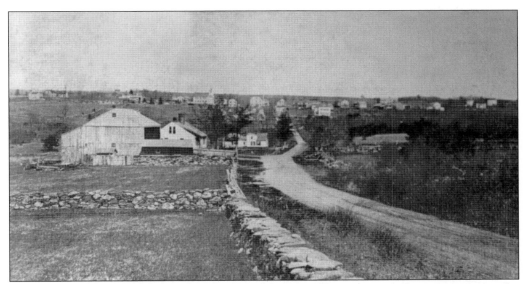

This postcard follows a still-unpaved West Street leading from Spencer to the town center at the top of the hill. The First Congregational Church steeple is in the upper left. The farm in the left foreground emphasizes the rural nature of the town, which continues today.

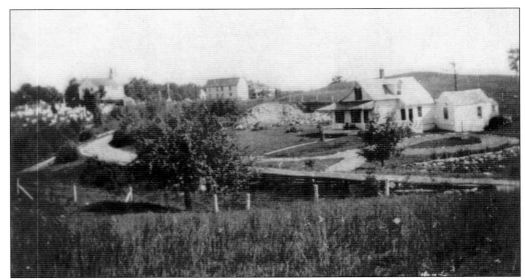

This photograph provides a distant view toward the town center. The First Congregational Church is in the upper left, with its steeple high above other buildings. Also seen are the open, rural spaces just outside the town center.

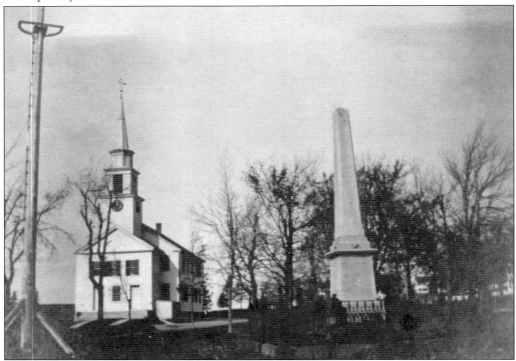

The First Congregational Church was rededicated in 1836 after its move from the town common, where it had served as the original meetinghouse. When the building was moved, it was also rotated, expanded, and renovated, with a steeple and a bell added. It is seen here prior to a major expansion many years later. The Civil War monument and flagpole still stand in front of the church today.

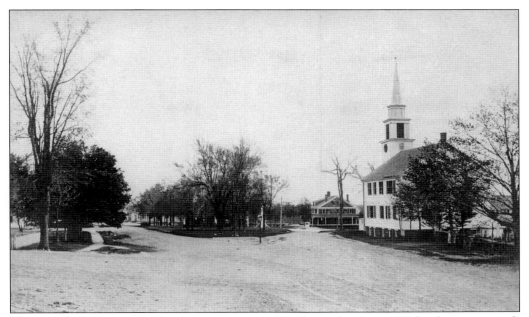

The First Congregational Church is seen here in 1905 from what is now Richards Avenue, with the Paxton Inn just beyond the church on the corner of Pleasant and West Streets. This was an important stop for the stagecoach and travelers on the Worcester-Barre route for many years.

This postcard shows a panoramic view of the town common. From left to right are the Paxton Inn with its large porch, the Civil War monument, the town flagpole, and the town hall, which was dedicated in 1888.

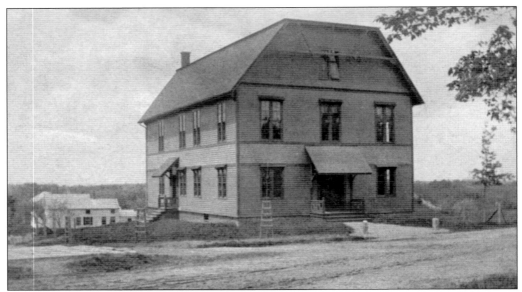

The town hall was built in the Victorian stick style and dedicated on November 1, 1888. Hon. Ledyard Bill, a state senator and town selectman as well as the author of 1889's *The History of Paxton* and the contributor of the first books establishing the town library, donated the land to the town. The estate of Simon Allen contributed $1,500 to supplement town funds for the building. The Allen Auditorium, on the upper level, commemorates the bequest. For many years, it was a popular location for dances, the town Christmas Eve party, school presentations, and other meetings and social events. It is not currently used due to its lack of compliance with state laws requiring accessibility.

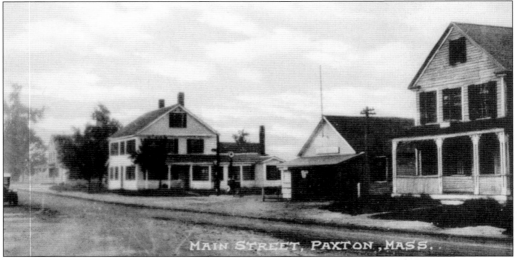

This postcard is important evidence of what has been called "the postcard age" in a recent exhibition at the Museum of Fine Arts in Boston. While people have come to accept almost instantaneous visual and textual communication in the contemporary world, postcards served that role around 1900 in Europe and the United States. Visitors coming to even a small town such as Paxton would have had a wide range of postcards from which to choose, allowing them to share their experiences at a reasonable cost.

Paxton sent 33 men to fight in the Civil War, 7 of whom died. After the end of the war, the town appropriated $500 for this monument, with an additional $300 raised by subscription. The iron fence surrounding the monument was a gift from the Ladies Social Union, as the project was consistent with their commitment to education, the town, and the church. The cannons at each of the corners, partially buried and symbolizing peace, were presented by the US Congress under the auspices of Hon. Ledyard Bill and Congressman W.W. Rice of Worcester. The iron railing was recently removed.

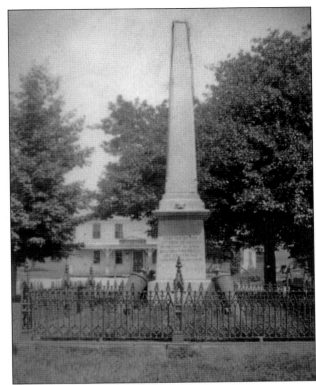

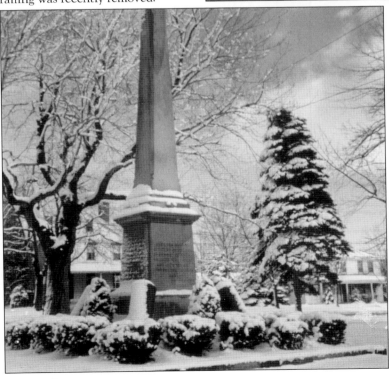

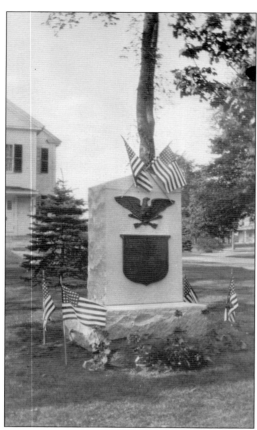

This monument to World War I veterans was dedicated on the town common on July 4, 1929. In 1948, the honor roll of the 22 townsmen who served was engraved on the marble slab. It replaced one sculpted and donated by internationally renowned sculptor Andrew O'Connor Jr., who lived in Paxton for a decade.

The house in the right foreground near the First Congregational Church, known as Ladd's house, was at the corner of Richards Avenue and Maple Street. It was built in stages. First, a boot shop was added beneath the barn, then a kitchen and an additional story were added, followed by the full home in the Greek Revival style. The series of buildings was demolished in the 1960s.

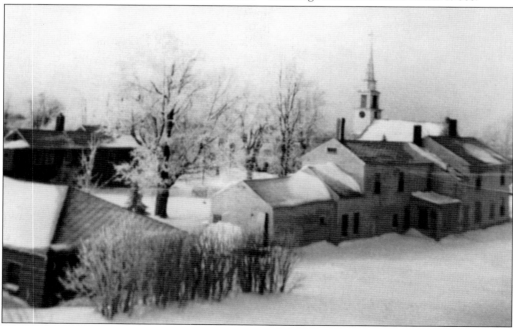

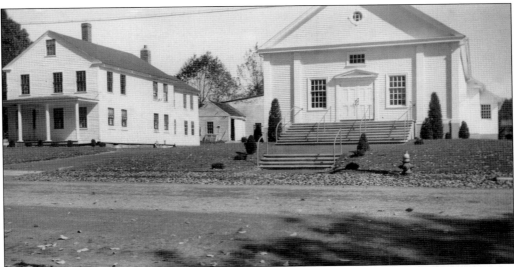

St. Columba's Catholic Church was a later addition to the common area. The land was purchased from Arthur Maccabee in 1948, but, for several years, mass was still celebrated in the town hall. Ground was broken in 1952 and the first mass was celebrated in the new building on July 27, 1952, with Rev. Harry A. Brabson as the founding pastor.

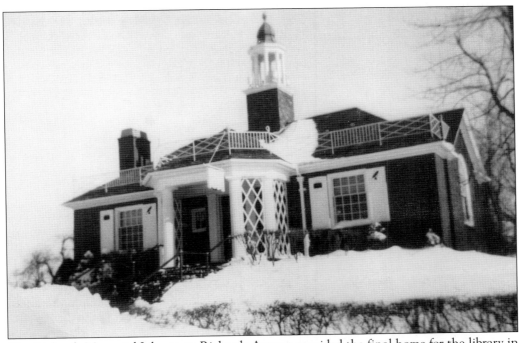

The Richards Memorial Library on Richards Avenue provided the final home for the library in Paxton. It was opened in 1926 because of the philanthropy of Ellis Richards. Although he worked in New York City, Richards had strong ties to Paxton and spent summers here. He donated the land and funded the building, and his estate provided a trust for the care and maintenance of the library.

Long referred to as the White Building, this structure was originally opened in 1900 as Paxton Center School, consolidating five much smaller schools dispersed throughout the town. Today, it has been renamed the John Bauer Senior Center and it is home to the Council on Aging and the Paxton Historical Commission. It also provides meeting rooms for town committees and private organizations.

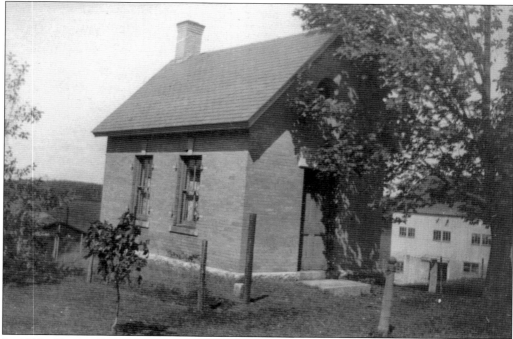

In 1899, Charles Boynton funded the town's records building because of his concern for the preservation of historical documents for the future. In the background is the Maccabee blacksmith shop, which was on the site of the present shopping area that includes the Paxton Market Place, the Pampered Pet, Barre Savings Bank, and Farrar Press.

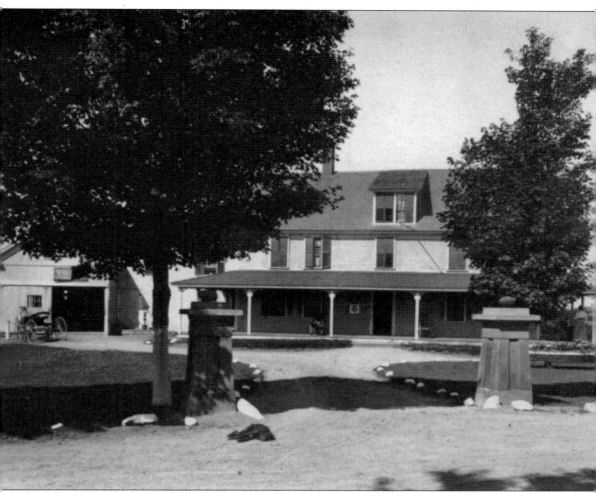

For many years, the Paxton Inn was an important stop on the Worcester-Paxton-Barre stagecoach line. It is seen here as a well-cared-for inn. In its long history, the building was also used as a barracks for the state police and then as a restaurant again before it burned down in 2001.

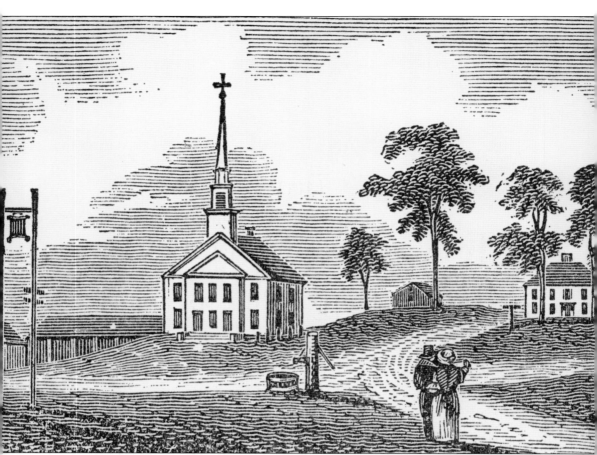

This illustration taken from a wood engraving depicts the First Congregational Church but as a somewhat modified and idealized image. The roads are repositioned, the area is cleared around the church, and an exceptionally large cross is prominently placed on the steeple. This image was reproduced in a book entitled *Massachusetts Towns—An 1840 View* by John Warner Barber, an American engraver who published successful books on national, state, and local history, illustrating them with his own engravings. Born in East Windsor, Connecticut, he served his apprenticeship with a bank engraver before operating his own engraving business in New Haven. In the 1830s, he set out in a horse and wagon to sketch and later engrave images of New England towns for his books.

Two

Town Government
and the Church

For early English colonists like the Pilgrims of Plymouth Colony and the Puritans of the Massachusetts Bay Colony, church and state were inextricably connected, and the Congregational Church was the official church. The church structure, called a meetinghouse, was an essential part of town life, and the residents of Paxton voted to begin the construction of their meetinghouse soon after the town was incorporated on February 12, 1765. The building was located on the town common and served the dual functions of town governance and religious worship.

Currently called the First Congregational Church of Paxton, the former meetinghouse was moved from its original site to a location near the town common and rededicated in 1836. When it was moved, the structure was rotated, expanded, and renovated, and a new steeple and bell were added. The bell was purchased from and cast at the Revere Copper Company and reportedly retrieved by Deacon David Davis, who brought it back to town with his wagon and oxen.

Although the official separation of church and state in Massachusetts had occurred by the 1830s, Paxton town offices were still located in the first floor of the church, and the town library was housed where the Sunday school met. By the mid-1800s, there was a growing trend to physically separate the two, and many towns began constructing town halls. Paxton joined this movement, with Hon. Ledyard Bill donating the land for the town hall and the estate of Simon Allen, whose name was given to the upper-story auditorium, supplementing town funds with an additional $1,500. Dedicated on November 1, 1888, the town hall housed some town offices and the town library until the Richards Memorial Library opened in 1926. Over the years, it also housed the police and fire departments, and the basement lockup was used until the 1930s to detain vagrants.

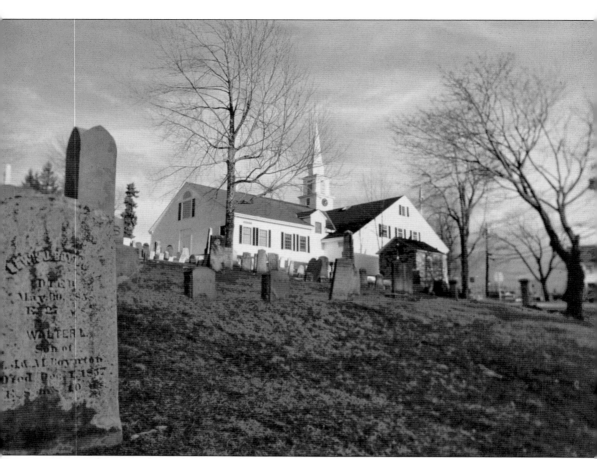

This modern view shows the First Congregational Church, as seen from the cemetery. Still sometimes referred to as the meetinghouse, it was the first building the residents of the new town of Paxton voted to construct, in April 1765, just after the town's incorporation on February 12, 1765.

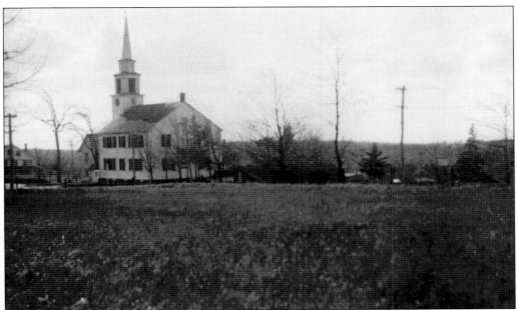

The early view of the First Congregational Church above was taken from near Richards Avenue. It shows the building after the February 24, 1836, rededication but before further additions were added. The early cemetery begins sloping down to Pleasant Street on the far side of the church. The gravestone at right honors the service of George O. Peirce, one of the town residents who volunteered to fight for the Union in the Civil War. He died on July 21, 1862, at Harrison's Landing, Virginia, after the Seven Days Battles, which caused large losses on both sides.

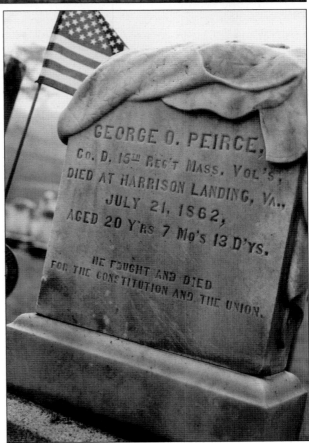

GEORGE O. PEIRCE,
Co. D. 15th Reg't Mass. Vol's,
DIED AT HARRISON LANDING, VA.,
JULY 21, 1862,
AGED 20 Y'rs 7 Mo's 13 D'ys.

HE FOUGHT AND DIED
FOR THE CONSTITUTION AND THE UNION.

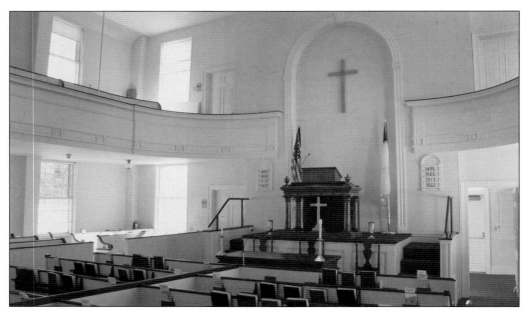

When attending services at the First Congregational Church, men and women sat separately in what was called "gendered space" and even used separate staircases. The Sunday services were longer than most modern services, often lasting three or four hours. In the winter, foot stoves were brought in to the pews, women often wore muffs with hot stones for warmth, and the minister preached in an overcoat and mittens.

The pews reserved for local slaves were at the far corners of the upper balcony, at the farthest point from the altar. Originally, there were two areas, but only one survives today, in the upper right. Prior to recent changes, the iron ring that slaves' leg irons used to be tied to was still bolted into the floor.

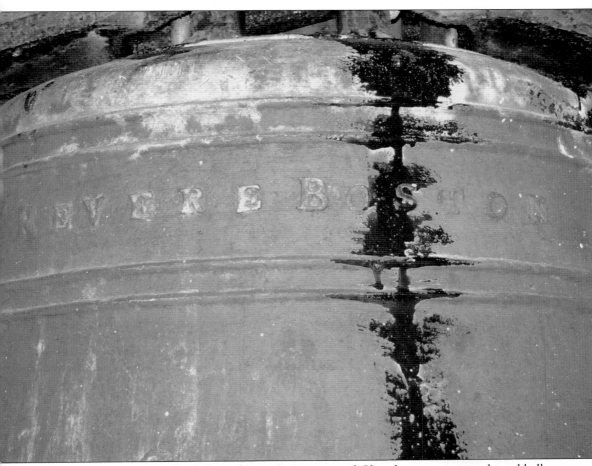

In 1836, the relocated and rededicated First Congregational Church got a new steeple and bell. The bell came from the Revere Copper Company. Paul Revere, a patriot and a skilled silversmith, was made famous by Henry Wadsworth Longfellow's poem about Revere's ride on April 18, 1776, warning of the British approach. Revere established a foundry in 1792, which his sons Joseph and Paul Jr. operated long after Revere's death in 1818. At the Revere Copper Company, officially established in 1828, Joseph Warren Revere oversaw the production of these bells. They were made of 75 percent copper and 25 percent tin, with trace amounts of zinc, lead, arsenic, nickel, and silicon. Some silver was also added to give the bell a better tone.

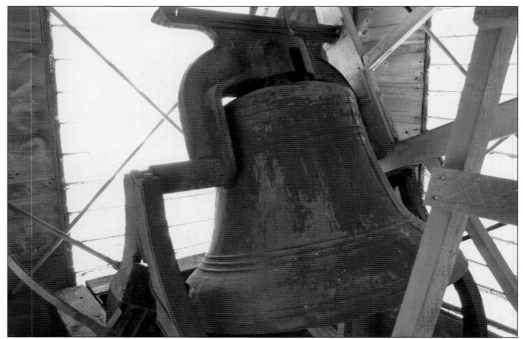

David Davis, the deacon of the First Congregational Church, reportedly retrieved the Revere bell with his wagon and a team of oxen. Although most reports tell of him traveling to Boston, it is most likely that he headed to Canton, where the Revere foundry moved shortly after its establishment.

Bells were an important regulator of daily life. The Gabriel bell woke the people in the parish. The Sermon bell announced the time for church services. The Pardon bell rang before and after the sermon, during prayers pardoning sins. The Pudding bell told the household cooks to prepare dinner for churchgoers, and the Passing bell tolled three times to mark a death, with subsequent tolls for each year of age.

Joseph Revere, Paul Revere's son, traveled to England to learn more about bells and their casting. He reported that bells made here and in England were meant to be rung by a wheel, and that an improperly rung bell was in danger of cracking. When a Revere bell was sold, the company would demonstrate the proper methods for hanging and ringing the bell and give a 12-month warranty. Today, there are still 134 bells with the Revere name. Most are in New England and almost half are in Massachusetts. Paxton is indeed fortunate to have such a bell. The Revere bell will be rung on the 250th anniversary of the incorporation of Paxton, on February 12, 2015.

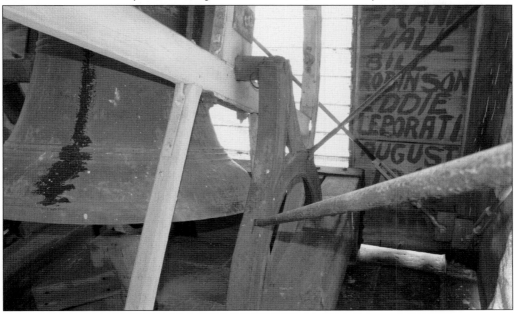

This certifies that in consideration of one Dollar, the receipt of which is hereby acknowledged I do give grant bargain and sell unto Ledyard Bill all my right title and interest to my Pew in the Congregational Church in Paxton, said Pew being No. 12. Also all my right title and interest in all the machinery and tools, owned by me in prosecuting the Boot business in Paxton.

Sept. 23d 1876
Paxton Mass.

John C Bigelow

The social status of an individual or a family was clearly indicated by whether they had their own designated church pew, and if so, where it was located. The closer the pew was to the altar, the more important they were. Once pews were purchased, a newcomer to town, like Hon. Ledyard Bill, for instance, would hope to purchase one if the opportunity arose. The image at left shows the terms of sale of a pew sold by John C. Bigelow to Ledyard Bill on September 23, 1876. Their signatures are below. It states that the purchase price was $1 for church pew number 12 in the Congregational Church in Paxton as well as the machinery and tools from Bigelow's boot factory. By this time, the boot industry in Paxton was waning after its height during the Civil War.

These two images show the First Congregational Church after the damage wrought by the hurricane of 1938 (below), and then after the structure was stabilized (right). The steeple was dismantled and later replaced, with the bell from the Revere Copper Company reinstalled. Interestingly, the clock still exemplifies the former linking of church and town government. The clock face continues to belong to the church, while the workings of the clock are the responsibility of the town. The 1938 hurricane came with little advance warning up the Connecticut River Valley. The Blue Hill Observatory in Milton measured sustained winds up to 121 miles per hour, and there was extensive damage all over New England, with much loss of property. It is estimated that several hundred lives were lost.

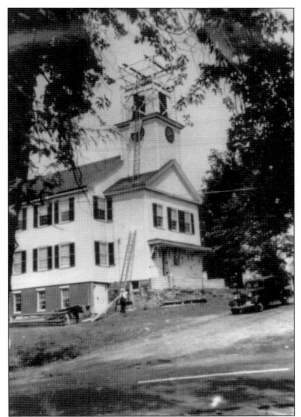

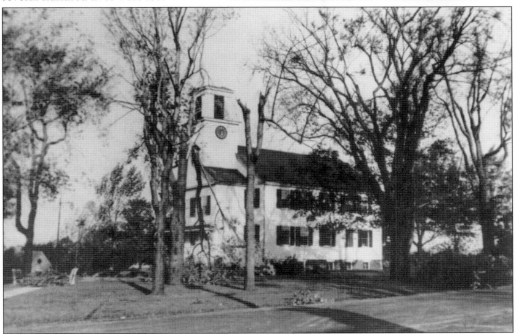

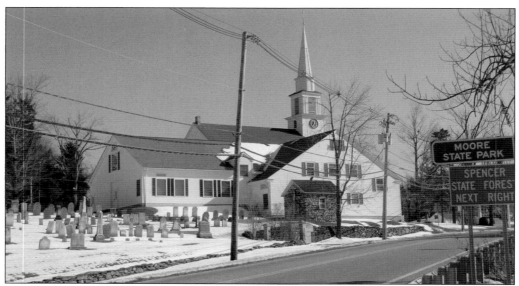

These recent photographs of the First Congregational Church show a number of expansions made to the building after its rededication in 1836. In order to adapt to a growing congregation in 1956, a new fellowship hall, new church offices, a new chapel, and an enlarged kitchen were added. On October 30, 1988, another addition was made, including a new chapel, a Christian education office, five new classrooms, a youth room, storage space, a general office, a pastor's study, and a new choir room. The entire building was also made handicapped accessible. During this time, the church worked with the Commonwealth of Massachusetts and archaeologists from the University of Massachusetts to navigate the site's history, especially because of the early cemetery. Today, the cemetery, which contains the graves of early Paxton residents, belongs to the town rather than to the church, and it is included in the historic district.

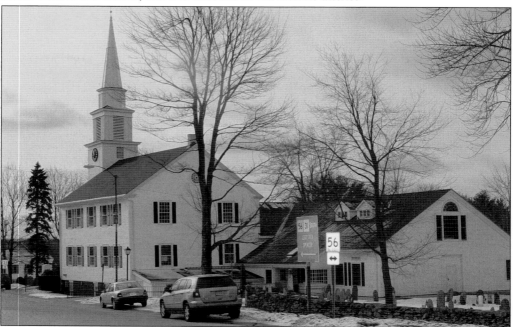

The image at right shows the list of pastors at the First Congregational Church, beginning with Rev. Silas Bigelow, who served briefly from 1767 to 1769, when he died at the age of 30 and was buried in the church cemetery. In *The History of Paxton*, Hon. Ledyard Bill wrote, "Under his ministry the kindliest of feeling had sprung up among all members of the society, and had his valuable life been spared to this people, much greater good must have been accomplished." The longest-serving pastor is the current one, Rev. Donald Whitcomb, who began his service in 1972. Below is the gravestone of Rev. Silas Bigelow, which is known for its unusual carvings. The upper-central area forms a background that appears as angels' wings, and in the center is a minister in a pulpit.

Ministers of the First Congregational Church
— of Paxton —

Silas Bigelow	1767-1769	Caleb Smith	1928-1932
Alexander Thayer	1770-1772	Eugene B. Smith	1932-1933
John Foster	1785-1789	Arthur Coulthard	1934-1936
Daniel Grosvenor	1794-1802	John Martin	1937-1939
Gaius Conant	1808-1831	James Morrison	1940-1941
Moses Winch	1831-1834	Ralph L. Krout	1941-1943
James Farnsworth	1835-1840	Robert L. Eddy	1944-1952
William Phipps	1841-1869	George Carpenter	1953-1954
Thomas L. Ellis	1871-1873	John Frederickson	1955-1958
F. J. Fairbanks	1874-1878	Bruce Van Blair	1959-1963
Otis Cole	1878-1880	Oscar E. Remick	1963-1966
John E. Dodge	1880-1887	Alvah M. Taylor	1966-1971
Alpha Morton	1887-1891	Donald Whitcomb	1972-
Lewis E. Perry	1894-1897		
Otis Cole	1897-1898		
George W. Clark	1898-1900		
George H. Pratt	1901-1912		
Thomas J. Lewis	1912-1914		
E. M. Rollins	1914-1915		
Edward L. Chute	1916-1927		

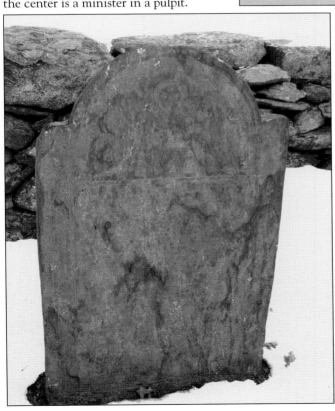

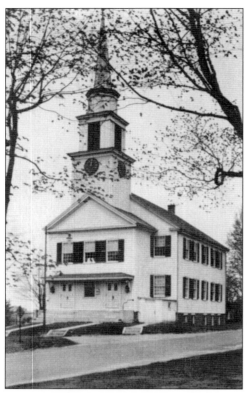

This postcard of the First Congregational Church shows it in its current site, in a commanding position at the apex of the long hill from the east, in Worcester, to the center of the town. The sheds housing the hearse were to the left of the church at this time, but they were consciously omitted from the postcard image.

The early photograph below of the town hall was taken around 1960, long after its dedication on November 1, 1888.

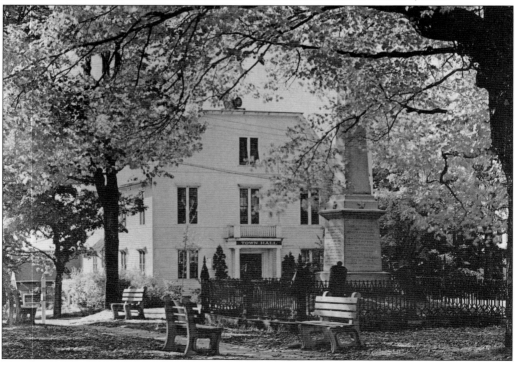

Three

AGRICULTURE, COMMERCE, AND INDUSTRY

Early settlers seeking land for agriculture came to the area in the 1740s. The Newton sawmill village, the remains of which are located in Moore State Park, included gristmills that ground grains into flour and sawmills that processed lumber as the land was cleared and homes and buildings were constructed. The lumber was also used for the expansion of the city of Worcester in the decades before and after 1900. Fortunately, the hilly countryside and plentiful water sources provided easy access to waterpower to run these mills.

Commercial and industrial activities expanded to serve the needs and desires of townspeople and others beyond New England. In town, there were local grocers, a private fire company, and a blacksmith. However, several industries began a local manufacturing boom in the mid-1800s, producing wooden boxes, palm hats, and shoes and boots. The latter were especially important, as there was a high demand for brogans, a sturdy ankle-high shoe used by diverse groups, including slaves in the South, Union soldiers, and, later, settlers moving westward after the Civil War. The end of the war and the demise of slavery decreased demand for brogans, and the industry faltered. A fire in 1873 destroyed the Bigelow boot factory, the largest surviving boot factory, causing the loss of many jobs. By 1890, the *Gazetteer of the State of Massachusetts* reported that there were only 31 men still making boots and shoes in Paxton.

Paxton became a popular stagecoach stop on the Worcester-Barre route, with the Paxton Inn serving weary travelers. The town's high elevation and cool summers drew visitors to the Asnebumskit House, the Summit House, and the Kenilworth Hotel.

Today, agriculture remains a component of contemporary life, with several local farm stands and garden nurseries in the area, but many residents work outside of the town, commuting to Worcester or to the Boston area. Several small businesses continue to provide services such as banking, dentistry, grocery and meat sales, pet care, and sports activities. The current major employers are the town government and Anna Maria College.

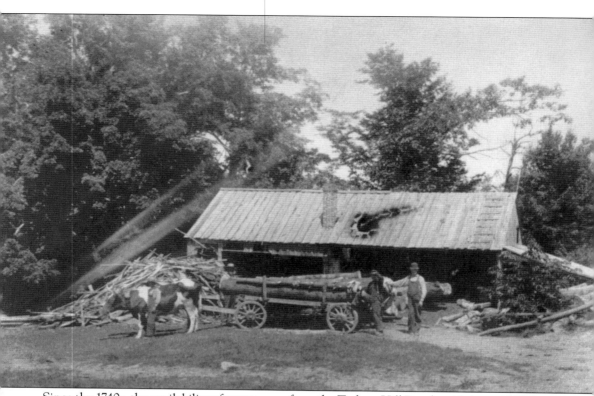

Since the 1740s, the availability of waterpower from the Turkeys Hill Brook, with its rapid 90-foot drop, attracted the construction of gristmills for grinding grain and sawmills for preparing lumber. Many mills were clustered in the Newton sawmill village, in what is now Moore State Park, but the Harrington Mill, seen here, was outside of that area. Here, a strong ox is hitched to a wagonload full of logs. The lumber was initially used for construction and firewood. Later, these sawmills also provided lumber to Worcester. The increasing population in the city created a strong demand for building materials and firewood. The amount of lumber cut in 1845 was recorded at 121,000 feet; by 1886, it had jumped to 600,000 feet.

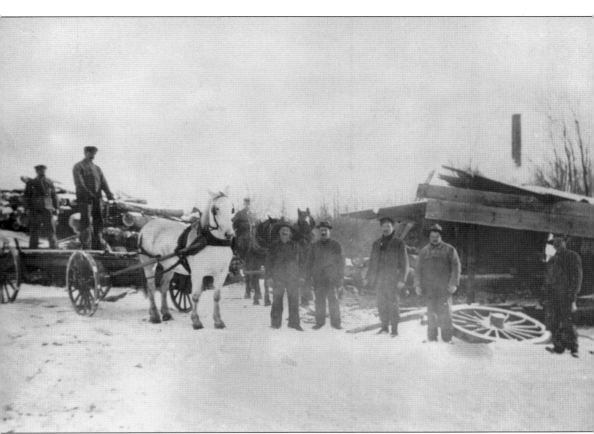

Several men pose for a photograph in front of a sawmill on a snowy day. It is likely that much of this lumber was being used for firewood, to meet the heating needs of homes and businesses. The ever-increasing demand for wood and agricultural produce for the expanding populations of Paxton and Worcester resulted in the clearing of much of the town's land. For much of the 1800s and the early 1900s, the town landscape was predominantly open. Later, when agriculture waned and there was less of a demand for lumber for construction and fuel, there was a substantial second growth of forest throughout the area. Archaeological excavations in the area of Moore State Park have exposed foundations dating back to the early settlement period of the town.

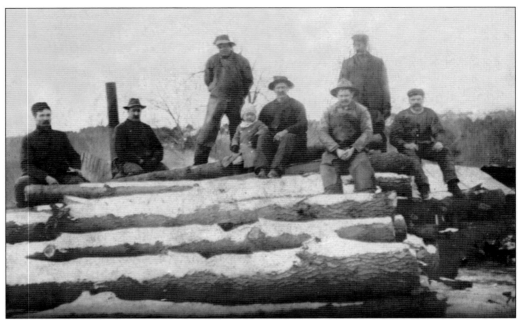

A group of lumbermen and a young child sit on logs in the winter. Often, family members worked in the same profession for several generations.

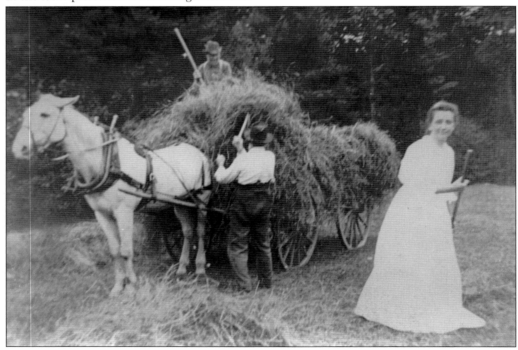

The desire to own land and farm was a strong attraction to settlers coming to the Paxton area, and from the early 1700s to the late 1800s, the economy was based on agriculture. The main products were hay, sheep and wool, cattle and meat, potatoes, butter and cheese, corn, and other grains. This image shows haying at the Pike farm.

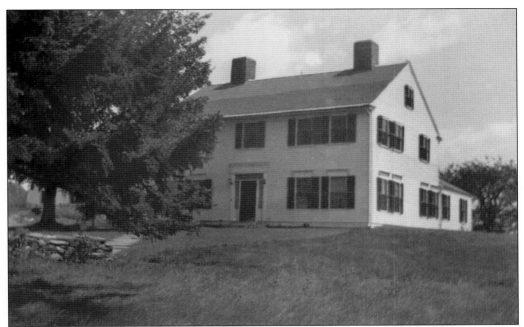

In 1865, Paxton recorded having 87 farms, but by 1905, the number had fallen to 74 farms. These images show the farm at 1028 Pleasant Street, with its large home (above) and dairy barn (below), which was owned by the Pierce family from 1934 to 2002. Legend says that there was an early skirmish on this site and that two Native Americans were buried there. It was used as an almshouse in 1769, housing those who were alone or needed care. It was constructed of hand-hewn timbers and handmade nails, with wide board floors. In 1934, Gliden B. and Esther R. Pierce purchased the property. Shortly after, it was being farmed by Robert B. Pierce and his family.

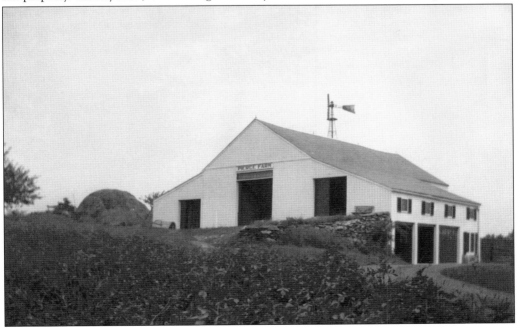

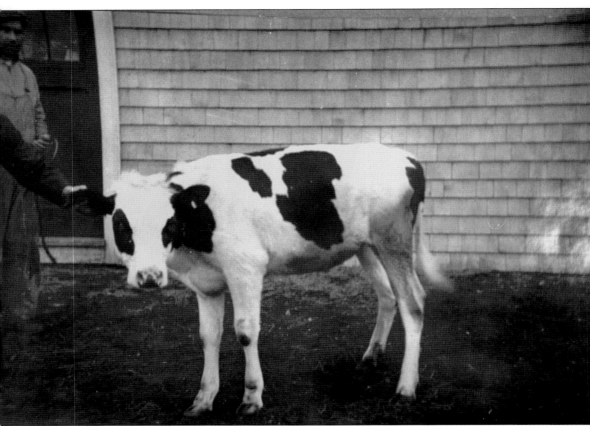

Dairying and market gardening were the two most important agricultural activities in the area. This cow is seen here in front of a barn. In the *Paxton Audio Journal* in 2011, George Ahearn recalled his experiences. "Well, we sold milk that we got from the cattle that we brought down there," he said. "We used to have to bring the milk up to the center of Paxton. And you know what that was like in the wintertime, we had a sled and the horses would fall down and break the harnesses. Oh what a time. But we made it through I guess."

Surrounded by an open landscape, Fox Hill Farm, on Davis Road, was owned by many generations of the Estabrook family. Unfortunately, the buildings seen here are no longer standing. In 2011, Frank and Doris Urbanovitch talked to the *Paxton Audio Journal* about market gardening. Doris recalled, "We used to get up in the morning and try to cut I'd say half a ton and we used to weigh it and tie it in boxes and brought it down, but you had to be there at 4 o'clock in the morning to unload, that was rhubarb. And raspberries, you wouldn't believe it, 5 cents a pint. And we had crates and crates of it that we shipped."

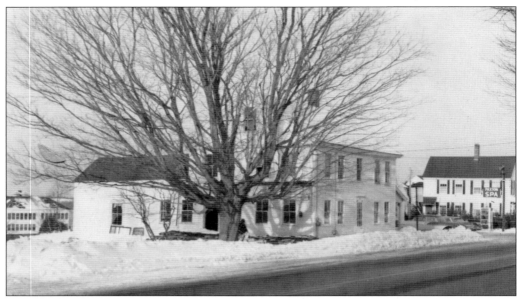

The Illig farmhouse was located on Pleasant Street. In 1938, the town purchased the home and the farm's 53 acres for $5,500 to be used for recreational purposes. For a number of years, the farmhouse was used as a two-family rental, but it was torn down in 1960.

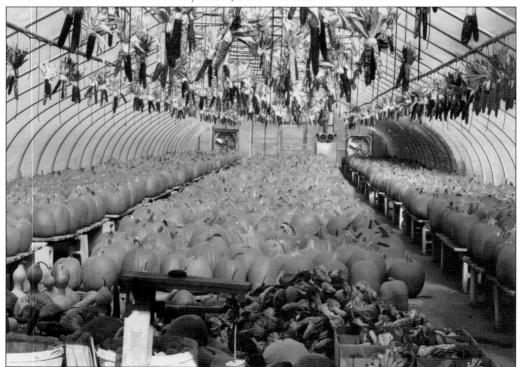

Local green markets continue to sell fresh vegetables in Paxton. Seen here is the vegetable greenhouse at Howe's, at the corner of Pleasant Street (Route 122) and Camp Street. In the winter, Howe's sells Christmas trees, wreaths, and garlands.

Cournoyer's farm stand also sells vegetables and fruits, which are grown in the fields adjacent to the house and market. The market usually closes by November 1. It is operated by several generations of the family and located on Grove Street, just past Anna Maria College.

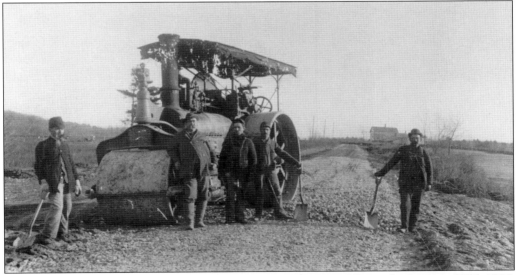

The Worcester-Barre state road (now Pleasant Street/Route 122) was laid out in 1895–1896. This group of workers poses for a photograph while building the road. Many of the stone walls originally lining the unpaved road surface were dismantled, with the stones broken up to help form the foundations of the early paved roads. Note the early steamroller, which was used to compress the stone and gravel.

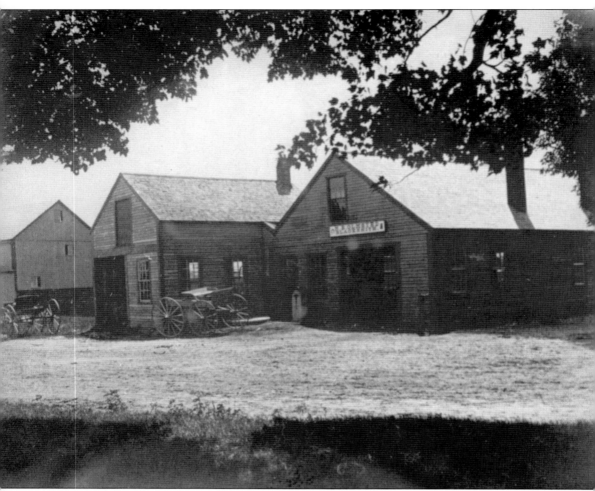

Blacksmiths were particularly important in agricultural communities, as they were needed to manufacture and repair agricultural implements, tools, domestic cooking utensils, railings, grills, and the like. Many were also able to shoe horses, as advertised in this sign of George Whitney's. This work required experience, as it was necessary to prepare the feet and fit the shoes carefully to avoid making a horse lame. No longer a necessity, blacksmithing has continued to this day as a niche industry and craft. At the Paxton Days festival held each June, a local blacksmith often demonstrates his expertise by making household implements.

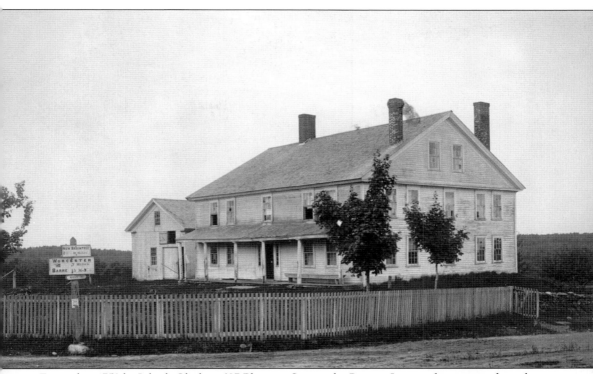

Erected in 1759 by Jobiah Clark at 687 Pleasant Street, the Paxton Inn was known as a hostelry, a stagecoach stop, and a restaurant. It was a welcome stop for stagecoach travelers on the Worcester-Barre route, but it appears abandoned here. This rare early photograph, dated between 1865 and 1880, shows the inn without a side porch or roof dormer. Note the sign in the lower left, indicating the directions and distances to New Braintree, Worcester, and Barre. In 1915, the inn served as the barracks for Company G of the state police. After that, it was again a restaurant until it was destroyed by fire in February 2001.

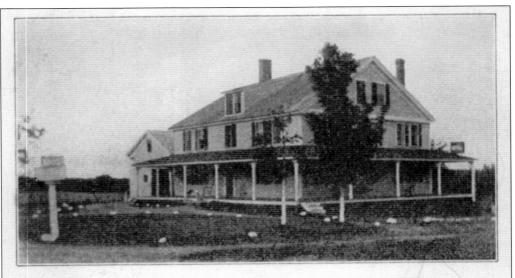

PAXTON INN, PAXTON, MASS. **J. F. DANIELS, Prop.**

The pleasantest old-fashioned hotel in New England, and home like in every respect.
Noted for its FISH and GAME meals. A beautiful drive over a state road from
Worcester. Parties can be accommodated at short notice.

LIVERY CONNECTED. TELEPHONE CALL, 881-6. [over]

PAXTON AND WORCESTER

STAGE LINE.

Leave Paxton, 8.00 A. M.,
Arrive in Worcester, 9.00 A. M.

Leave Worcester, 10.45 A. M.,
Corner Main and Pleasant Sts.,
Arrive in Paxton, 12.00 M.

Leave Paxton, 2.15 P. M.,
Arrive in Worcester, 3.15 P. M.

Leave Worcester, 4.45 P. M.,
Corner Main and Pleasant Sts.,
Arrive in Paxton, 6.00 P. M.

SUNDAYS.

Tally-Ho for Tatnuck.

Leave Paxton 11.00 for Tatnuck.
Leave Tatnuck for Paxton, 12.00 M.
Leave Paxton, 5.00 P. M., for Tatnuck.
Leave Tatnuck for Paxton, 6.00 P. M.

Single Fare, 35 Cents.

10 Round Trip Tickets, $6.00.

☞ *Tally-ho Parties a specialty.*

Paxton Telephone Call, 881-6.

J. F. DANIELS,
Proprietor Paxton Inn.

This Paxton Inn advertisement was made under the proprietorship of J.F. Daniels. It advertised the "old-fashioned hotel" with its fish and game meals and the scenic drive from Worcester. On the reverse are the schedules for provided transportation, which followed the old stagecoach route from Paxton to Worcester. Note that it took longer going up the hill from Worcester to Paxton than to go down the hill. The fare was only 35¢, but if one made the trip regularly, it was possible to get 10 round-trip tickets for $6, saving $1 overall.

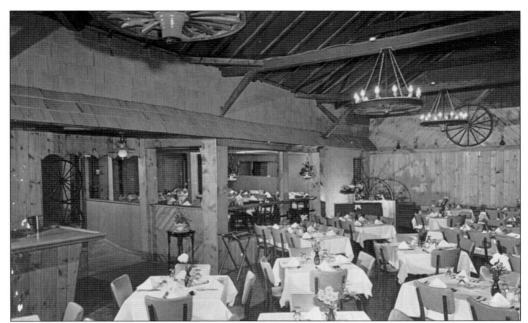

This postcard shows the Surrey Room at the Paxton Inn, with its tables set up for serving guests after the building became a restaurant again, harkening back to its earlier history as a stagecoach stop for weary travelers.

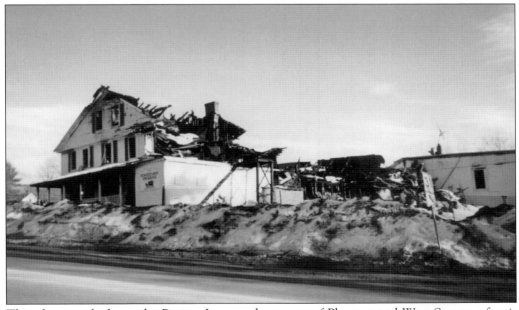

This photograph shows the Paxton Inn, on the corner of Pleasant and West Streets, after it sustained extensive damage from a major fire in 2001. Fire departments came from Paxton and from other towns, including Leicester. The building never reopened and was torn down. It was eventually replaced by the Country Bank of Paxton.

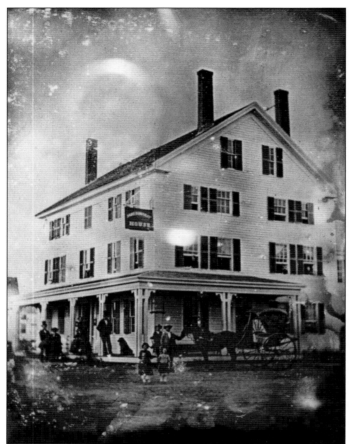

The high elevation of the town of Paxton, with the height of almost 1,400 feet above sea level at the top of Asnebumskit Hill, brought cooler, breezier summers. The town became a popular destination, as people in the cities became more affluent and mobile and sought venues in the nearby countryside to visit. The Summit House was the first hotel in Paxton, followed by the Asnebumskit House and then the Kenilworth Hotel. They all offered a quiet place to visit, and meals were usually included with the stay. The Asnebumskit House is seen at left, with guests and a carriage in front of it. There was also a nearby pond for fishing. Below is a postcard of the Kenilworth Hotel, located on Pleasant Street near the town common. The Kenilworth was also a multistory building with a large porch designed for relaxation.

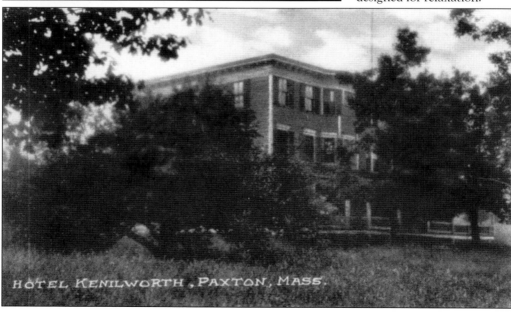

HOTEL KENILWORTH, PAXTON, MASS.

Mrs. A. A. Crouch.

KENILWORTH HOTEL
EDWARD J. FITZGERALD
PROPRIETOR

PAXTON, MASSACHUSETTS

The Kenilworth Hotel called itself an ideal "family hotel," with good cheer, accommodation for 50 guests, and excellent cuisine. It even featured a bowling alley and a pool as well as a croquet court and a private pond across the road. Rates at the time were $18 and $21 per week. The hotel could be reached by taking the Worcester Consolidated Street Railway to West Tatnuck in Worcester, where the long hill to Paxton begins and people could be transferred to local transport to the hotel. The hotel was destroyed by fire in 1926. (Both, courtesy of the Crouch family.)

numerous ponds throughout the neighborhood. Hunting in season for quail, partridge, rabbit, hare, fox, duck and deer is very good.

The Kenilworth Hotel is situated in the village, four miles from the terminus of the Worcester Consolidated Street Railway at West Tatnuck, where cars are met regularly five times daily by auto bus, and at any other time by appointment. The hotel is open the year round.

In the Kenilworth is found one of those ideal Family Hotels, where the dictates of extreme style and luxury have given way to good cheer, bright sunlighted interiors and the charming unobtrusive atmosphere of the private home. The Kenilworth is new and up-to-date in every way, with accommodations for fifty guests. The location is ideal; full southern exposure, wide porches and an excellent cuisine. It is an ideal resort for all seasons of the year; steam heated, fitted with electricity and baths, with running water in every room. Vegetables in season from the hotel garden. Eggs, milk, poultry and butter served strictly fresh; bowling alley and pool room across the road. Croquet court, private pond and pine grove adjoining hotel.

RATES $18 AND $21 PER WEEK.

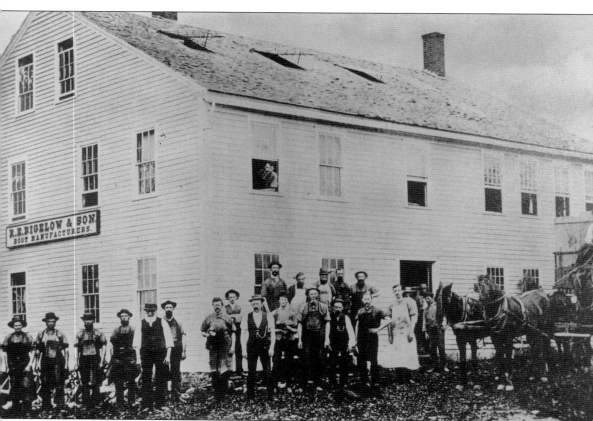

Ralph E. Bigelow and George S. Lakin founded this boot factory in 1823, following the lead of John Partridge, who had established the first boot factory in Paxton in 1820. The business of making boots and shoes, especially brogans, proved profitable. Business boomed during the Civil War; the factories became a major employer for Paxton and the surrounding towns when they supplied boots to the Union army. The sign identifying the factory as R.E. Bigelow & Son, Boot Manufacturers indicates that this photograph was taken after 1864, when Lakin left and Bigelow brought his son John C. Bigelow into the business. The building burned down in 1875, and there was no incentive to rebuild because the industry was no longer profitable after the end of the Civil War.

This photograph was taken from the porch of the Gould home at 612 Pleasant Street after the 1875 fire that destroyed the R.E. Bigelow & Son boot factory. It overlooks the barren area facing towards 604 Pleasant Street.

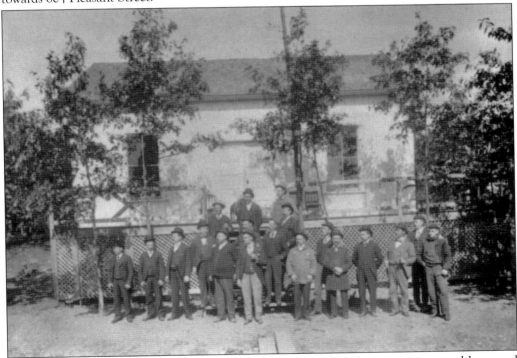

The boot industry fueled the economy in Paxton in the mid-1800s, spawning several large and small businesses. At its height, there were more than 500 men and women employed in this industry, with workers from other towns taking work home with them. However, by 1890, the *Gazetteer of the State of Massachusetts* reported that there were only 31 men still making boots and shoes in town.

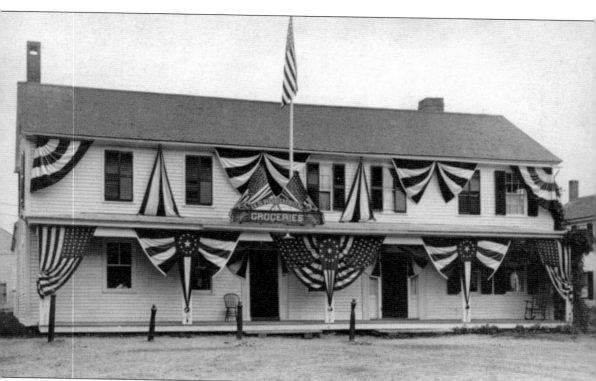

This store, once located near the town common, served as an important commercial and social hub in Paxton. Nathanial Pike and Moses Parkhurst originally built the store in the mid-1800s. It had many subsequent owners and operators, including Harvey Wilson, William Brewer, Nathanial and William Clark, Walter Clark, Herbert Robinson, Chester Rossier (in the 1920s), and D.C. Bliss. Nathanial Clark served as storekeeper and postmaster for over 40 years. He was appointed to the position of postmaster by Pres. Abraham Lincoln. In the 1890s, the first telephone in town was located in the store; reportedly, only town taxpayers were to use it at no cost. The store is seen here decorated in the red, white, and blue bunting that often adorned many of the town buildings for celebrations.

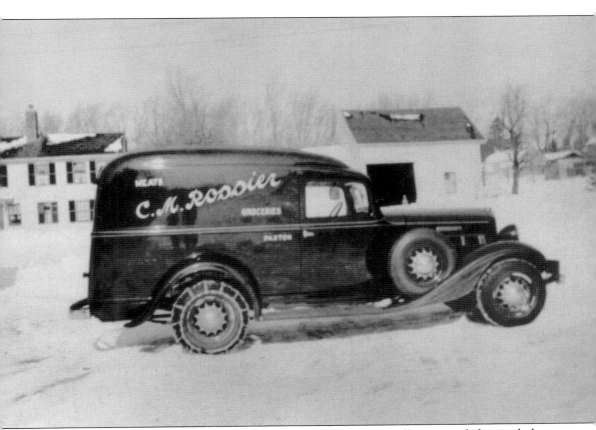

When it was operated by Chester M. Rossier, the store and post office expanded to include a service station that sold Socony gasoline. This delivery van advertising C.M. Rossier was used for transporting goods and delivering groceries. After being an important part of the town for decades, the store was torn down in the 1950s, and St. Columba's Catholic Church was built on the site. Until then, the First Congregational Church had been the only church in town.

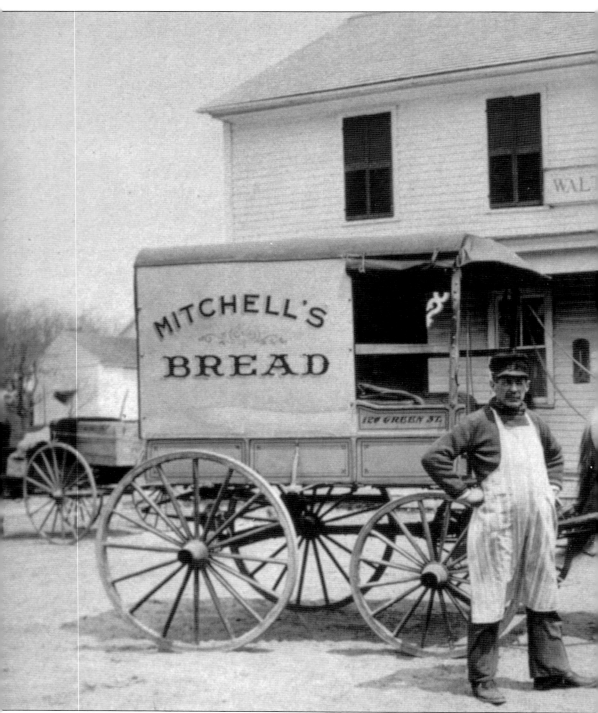

Frank Pierce stands in front of the Mitchell's Bread wagon. In the second half of the 1800s, horse-drawn buggies were used as delivery wagons. These wagons had oak frames with pine flooring and were pulled by a single horse, as seen here. They were especially popular in cities and towns,

where many people rented rooms and did not have kitchens for baking. Sellers would usually walk along the side of their wagons calling out their wares. The wagon is seen here in front of the general store and post office, which was owned by Walter E. Clark at the time.

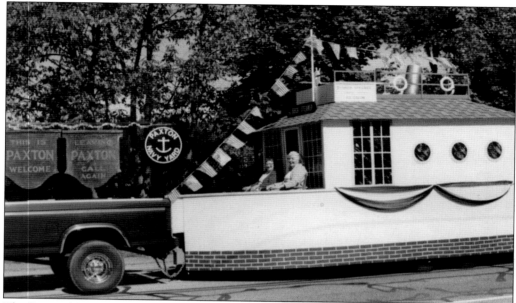

The Paxton Navy Yard takes its name from an early story recorded by Hon. Ledyard Bill in *The History of Paxton*. As the story goes, one of the passengers on the stagecoach was a sailor who was clearly inebriated. When the coach stopped for passengers to admire the view of the small lake on the site, and the sailor saw the forest near the water, he asked if this was the navy yard. The absurdity of the remark appealed to all given that Paxton is 50 miles inland at an elevation of over 1,100 feet! The name continued when the Clapp brothers opened a restaurant, designed as a dry-docked tugboat, and small zoo of common animals in 1930. Above, the Paxton Navy Yard sign is seen on the float in one of the town celebratory parades. It was an important part of town life and was located on much of the land that is now the Paxton Sports Center on Pleasant Street.

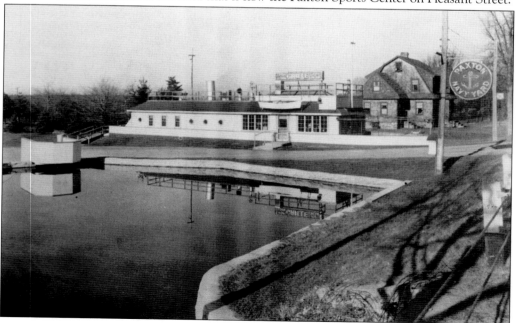

Four

A COMMITMENT TO EDUCATION

In 1769, just four brief years after the town was incorporated, a designated committee divided the town into five districts, or squadrons, formally beginning its dedication to education. These districts—northeast, southeast, southwest, northwest, and middle—served specific geographic areas, each with its own school, so that children could attend near their homes. Later, town residents voted to incorporate the five small districts into one central district, and, in 1898, the Paxton Center School was constructed on West Street. It was expanded in 1929. In 1957, a new Center School was constructed, and the older structure, then called the White Building, was eventually donated to the town to use for public meetings.

Today, the Wachusett Regional School District, founded in 1955, serves the towns of Holden, Paxton, Princeton, Rutland, and Sterling, with each town having one or more elementary and middle schools. In Paxton, children attend the Paxton Center School from kindergarten through eighth grade. Students then have the choice of attending one of two regional high schools, Wachusett Regional High School or Bay Path Regional Vocational Technical School in Charlton, which was opened in 1972 to provide an integrated academic and vocational technical education.

Many civic organizations throughout the town's history have also fostered a commitment to education. In 1824, the Female Reading and Charitable Society was formed. Later, the Lyceum Debating Society began meeting as well. The town library, originally comprised of books donated by Hon. Ledyard Bill, was first located in the Congregational Church, later moved to the town hall, and in 1926 was finally housed in its own building, the Richards Memorial Library.

In 1952, Paxton welcomed Anna Maria College, a private, four-year, coeducational institution founded in 1946 by the Sisters of St. Anne. Rooted in the Roman Catholic tradition, the college currently has approximately 1,500 undergraduates, and the town and college share a collaborative relationship.

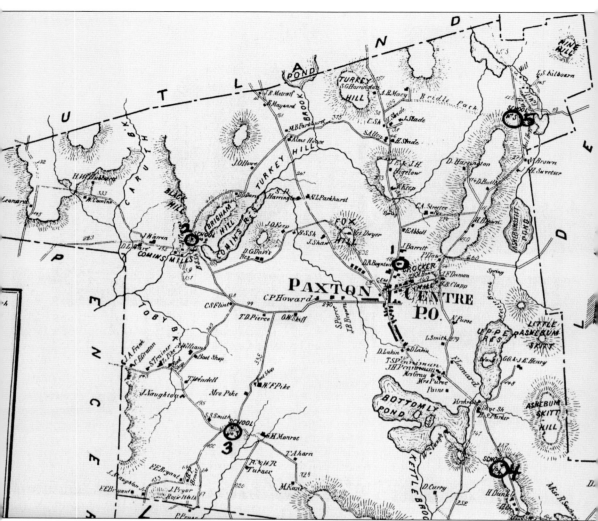

After the first school districts, or squadrons, were created in 1769, one teacher usually taught children from several different grade levels. Once the Paxton Center School was established in 1899 to consolidate the educational system, these small schools closed and the buildings were sold. There were many changes in education in New England in the late 1700s and early 1800s, especially for girls. In 1789, the Boston public primary schools became coeducational, and after 1852, public high schools for girls began to open.

This photograph shows the second Paxton Center School, at 46–50 Richards Avenue. It replaced the original Paxton Center School, which was also called School No. 1 and was used until 1898, when it was moved adjacent to the town hall and became a residence. It had been located in the vicinity of 112 Richards Avenue, near the town center.

The Northwest school, or School No. 2, was built on land that later became the estate of Florence and Fred Morton. This district school permanently closed in 1899 due to a shortage of students and the consolidation of public education at the new Paxton Center School. It was incorporated into the manor house by its new owners, the Mortons, and the land eventually became part of Moore State Park.

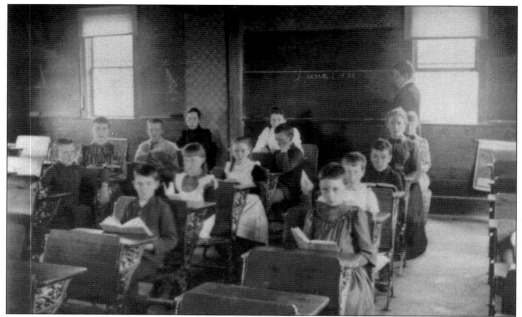

This photograph shows the interior of a schoolroom on June 1, 1891, which is written on the blackboard. In these early schools, one teacher taught students of varying ages and levels in one classroom. All the small schools were closed soon after the boot industry collapsed and people moved away. The population of the town dropped precipitously in that era: there were 820 residents in 1850, 646 in 1870, and only 471 in 1915.

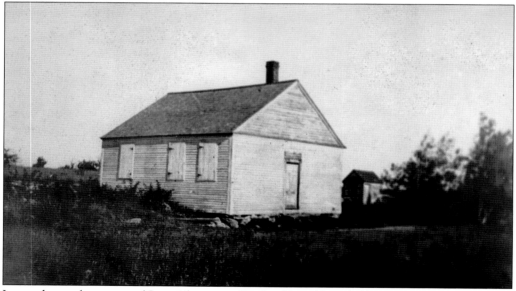

Located near the corner of Suomi (meaning "Finland") and Marshall Streets on what was called Pudding Corner Road, the Southwest school was also called School No. 3, the Hill school, or the Pudding Corner school. In *Landmarks and Memories of Paxton*, Roxa Howard Bush states that the name came from the puddings that area residents carried to the ordination of a minister. This building was sold in 1899, used as a temporary dwelling, and then dismantled.

The Northeast school, also known as the Pine Hill school or School No. 5, was at the end of Grove Street near the intersection of Pond Street. After the central school was constructed and the district schools were closed, this building was purchased by a Mr. Arsenault of Rutland, moved from its site, and then used as a barn.

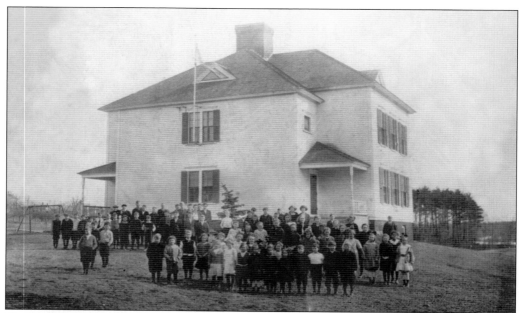

The photograph above is one of the earliest images of the Paxton Center School, taken around 1900. At that time, the school had approximately 60 students and 7 teachers. There were outdoor bathroom facilities until 1913, when running water was installed, followed by electricity in 1919. It was constructed with four rooms on two floors, with two grades being taught in each room. Although it is still often called the White Building, today it has been officially renamed the John Bauer Senior Center. It now houses the Council on Aging and the Paxton Historical Commission and also provides meeting rooms for town committees and private organizations. It is near the town center on West Street (Route 31) as it heads towards Spencer. The building is seen below years later.

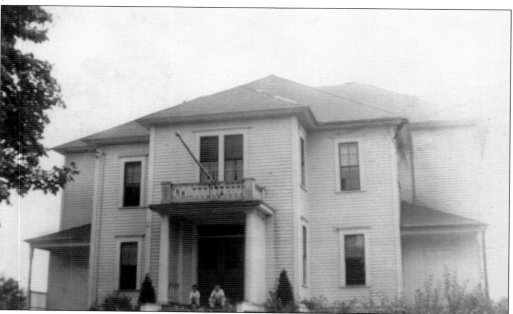

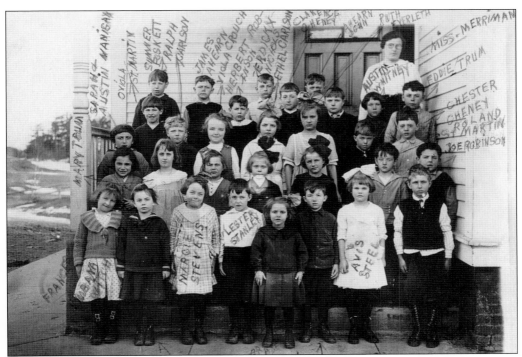

The owner of this photograph attempted to identify the members of Anne Merriman's class at the Paxton Center School in 1921. Viola Crouch, who is third from the left in the third row, later served as Paxton's librarian and was better known as Vi Crouch Prentice. Below, teacher Ethal Swanson (fourth row, far right) poses with her Paxton Center School students in 1928. Her 41 students were in grades one and two. Women had limited opportunities in that era, and teaching was one of the few accepted professions open to young women in the 1700s, 1800s, and early 1900s.

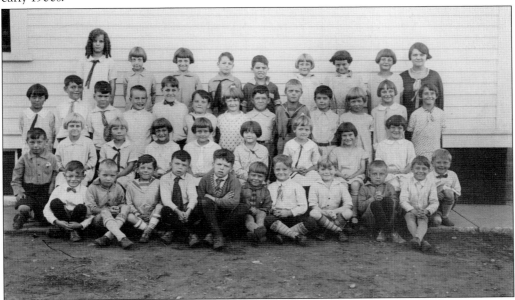

This high school class photograph includes both young men and women, a sign that women's educational opportunities continued to expand.

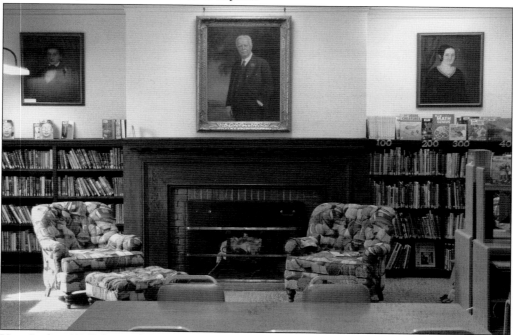

Hon. Ledyard Bill donated the first collection of books to the town in 1877. They were originally housed in the First Congregational Church and then at the town hall after it was completed in 1888. In 1926, the Richards Memorial Library, the interior seen here, opened as the first building used solely as a library. Ellis Richards, seen in the central portrait over the fireplace, donated the land at the corner of School and Maple Streets after moving the Goddard house.

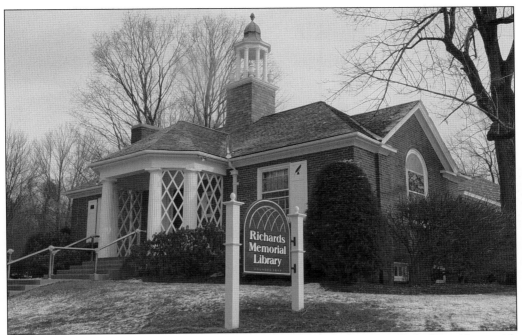

Ellis Richards had extensive ties in Paxton, although he worked in New York City. Along with the library site, he also donated the necessary funds for its construction and left 3/25ths of his estate in a trust for the library's care and maintenance. The trust was augmented in 1933 by an additional bequest from Edward Bigelow. An addition was made to the building in 1976, and today, library services include computer access to different collections and the online catalog for all public and private libraries in the region. Paxton patrons now have access to more than six million volumes. The library also offers activities and programs as well as passes to museums provided by the Friends of the Richards Memorial Library and the Paxton Cultural Council.

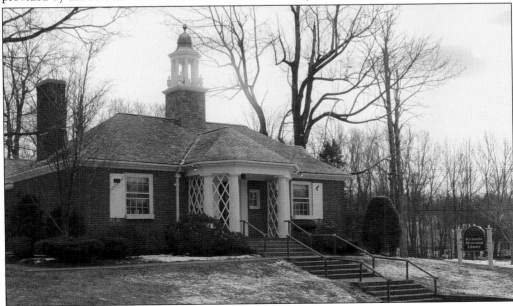

Soquet House, once the home of David Harrington, served as the convent for the Sisters of St. Anne when they moved Anna Maria College to the 192-acre farm in Paxton in 1952. Founded in Quebec more than 150 years ago by Esther Blondin, later called Mother Marie Anne, the order's commitment to teaching has continued. In 1946, the Sisters of St. Anne founded the college, and in 1951, they purchased the land in Paxton. While the college first sought "to make higher education available to women of modest means," Anna Maria College is now a private, coeducational Catholic liberal arts college. Offering associates', bachelors', and masters' degrees, certificate programs, and online courses, the college is accredited by the New England Association of Schools and Colleges. Their new online nursing program has been approved by the Massachusetts Board of Registration in Nursing. Many of the educational and cultural events at Anna Maria College enhance the quality of life for town residents.

Five

PEOPLE AND PLACES

Paxton has a rich history because of its people and the places connected to them. The stories linked to centuries of residents live on in a blend of fact and fiction. The architectural history is also complex. Several early sites and buildings survive, but many of them have been transformed and/or moved to new sites. Others burned or were razed and are known today only from text and images.

This chapter highlights a few well-known people who resided in Paxton and made substantial contributions to its history and connects them to specific places or sites in town. Some of the notable residents are from the time of the American Revolution. Maj. Willard Moore and Capt. Ralph Earl fought in support of the revolution, while others, such as Charles Paxton, James Earl, and Ralph Earl Jr., left for England. Other well-known residents include authors Roxa Bush Howard, who wrote *Landmarks and Memories of Paxton* in 1923, and Hon. Ledyard Bill, a state senator, selectman, and prominent businessman, who wrote the definitive *The History of Paxton* in 1889.

Charles Boynton was the benefactor of Boynton Park, which borders Paxton near the Worcester-Holden line. Ellis Richards donated the land and the funds to establish the Richards Memorial Library. John Bishop was involved in the construction of the Chapel at West Point and the Antiquarian Society in Worcester, and internationally acclaimed sculptor Andrew O'Connor Jr. lived and worked in Paxton for a decade.

There are many others who have faded into the historical record, and the hope is to bring out their stories as well, including the stories of Abigail (Hagar) Livermore, who supported the American Revolution, and Aaron Occum, who was reported to be the last member of the Nipmuc tribe living in the area near Paxton. The history of these people and places are inextricably woven together, leaving a rich legacy for present and future residents.

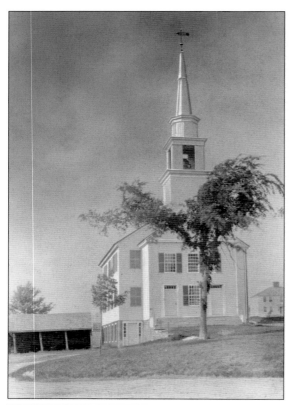

The bell for the church steeple was originally promised by Charles Paxton, the town's namesake, but never given. In 1760, he became the surveyor of customs for Boston harbor, an unpopular position given the taxes he had to levy. He was hung in effigy on Boston's famous Liberty Tree and was described as "every man's humble servant, but no man's friend." He left for England in 1776 and died there in 1788. The town finally purchased a bell from the Revere Copper Company. Deacon David Davis retrieved it with his wagon and oxen, and the bell was installed in the steeple in 1836 (below). In the image at left, note the sheds to the left of the church, which kept the hearse.

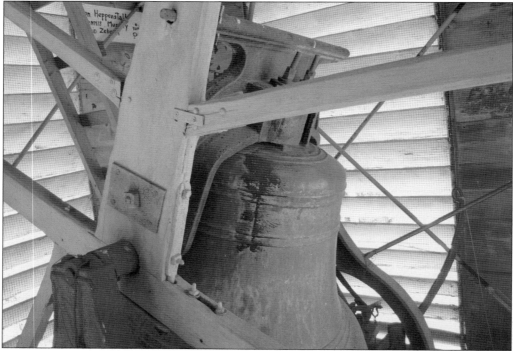

Built for the Joseph Penniman family around 1739, this home at 508 Pleasant Street was purchased in the early 1760s by the Capt. Ralph Earl family. In *The History of Paxton*, Hon. Ledyard Bill wrote, "Captain Earl is one of the most prominent people to have lived in Paxton." Earl served as captain of the 7th Company in Col. Samuel Denny's 1st Worcester County Regiment of the Massachusetts Militia. The Denny family later commissioned a painting from his son Ralph Earl Jr. upon his return from England. A marker remains at the corner of the property, and the inscription reads, "Here lived Ralph Earle of the Revolution and also Ralph Earle Jr. and R.E.W. Earle Artists." The home below was located on Asnebumskit Hill and once belonged to Rev. Silas Bigelow, who was the first minister at the First Congregational Church from 1767 to 1769, when he died at the age of 30.

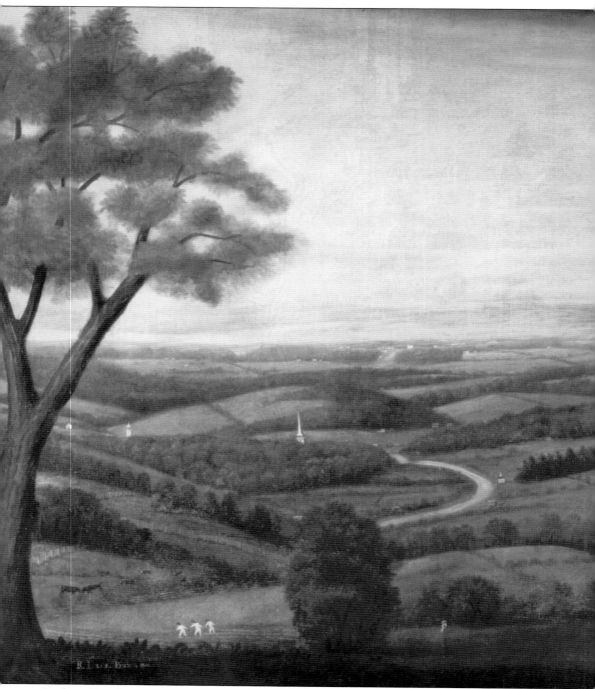

Looking East from Denny Hill, painted in oil on canvas in 1800 by Ralph Earl Jr., was likely commissioned by Col. Thomas Denny Jr. The Earl family farm was in the portion of Leicester that was incorporated into Paxton. At the time of the American Revolution, the family had split loyalties. While the father, Capt. Ralph Earl, served in the Continental army, Ralph Earl Jr.

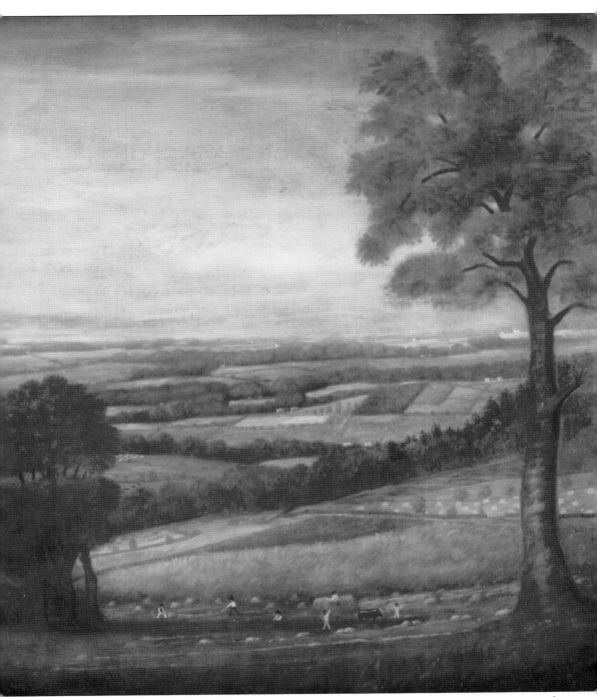

and his brother James left for England to continue their artistic training with the assistance of another American, Benjamin West, who was the appointed history painter to King George III. Both brothers eventually returned to become successful landscape and portrait painters after the revolution, with Ralph Jr. settling in Connecticut and James in South Carolina.

This home at 216 Richards Avenue is the home of the parents of Maj. Willard Moore, who died at the Battle of Bunker Hill on June 17, 1775, and for whom Moore State Park is named. The property was part of the Moore farm, which Peter Moore inherited. It was in the portion of Rutland that was incorporated into Paxton in 1765.

The St. Columba's rectory at 20 Richards Avenue was originally built by Sylvester Brown for his niece Ellen F. Clark. Her father was Hollis Howe, who served in the Civil War and died at the Battle of Yorktown in 1862. At one time, the general store and post office built by Moses Parkhurst and Nathaniel Pike was next door.

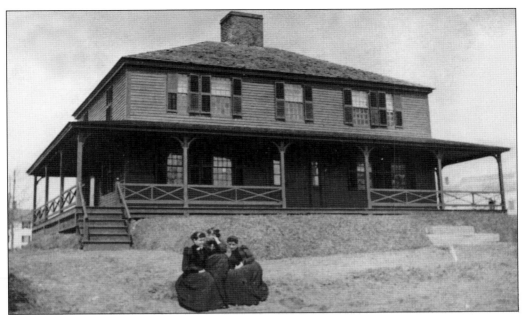

The Goddard house was built in 1739 on land that was once part of Rutland and was later incorporated into Paxton. Named for Tyler Goddard, it was originally at the corner of the roads to Rutland and Holden. In 1902, Ellis G. Richards purchased the home, and later, he had it moved to 112 Richards Avenue, where it still stands today. Its former site is now occupied by the Richards Memorial Library, which Ellis G. Richards gave to the town, along with support for the construction of the library building and an endowment for its continued operations. Here, the house still has its centralized chimney, which was removed when the house was relocated.

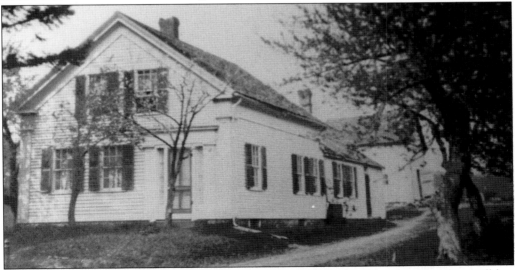

This house at 632 Pleasant Street, recently owned by the Stone and Lombard families, still has its Greek Revival–style facade and many architectural attributes, including the gabled roof, the emphasis on the cornice line of the main roof, and the elaborated front door with narrow sidelights. By 1919, a porch was added that largely obscured some elements, but interior features such as the wide pine floorboards still exist.

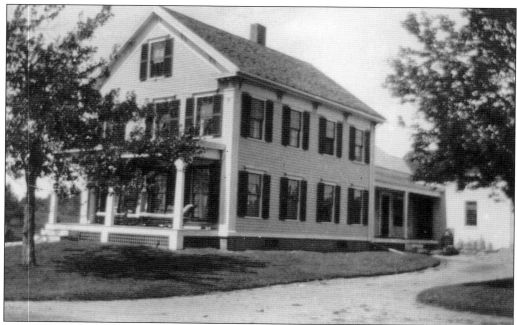

This two-story frame house in the Greek Revival style at 592 Pleasant Street was built between 1854 and 1857 for Daniel Lakin, whose family had moved to Paxton from Pepperell. The carpenter is identified only by the area he came from: Barnes of Coldbrook, an area that is now part of the town of Oakham. Like many of the houses of this period, it has wide board flooring.

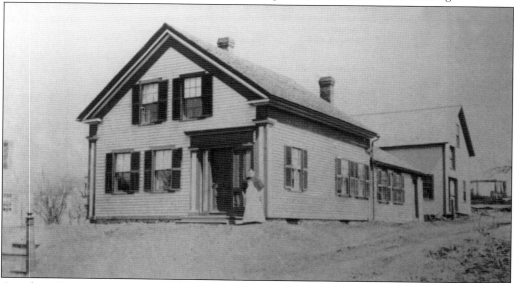

Another Greek Revival house, built around 1840 by Prescott Grosvenor, is at 628 Pleasant Street. This early photograph shows the main house, the ell, and the two-story barn. A shed and outhouses are outside of the picture, but they were destroyed along with the barn in the hurricane of 1938. Later, there were repairs and changes made to the house, with a second story added to the surviving ell and a garage added in 1954. The woman standing in front of the house is believed to be Mrs. Aker.

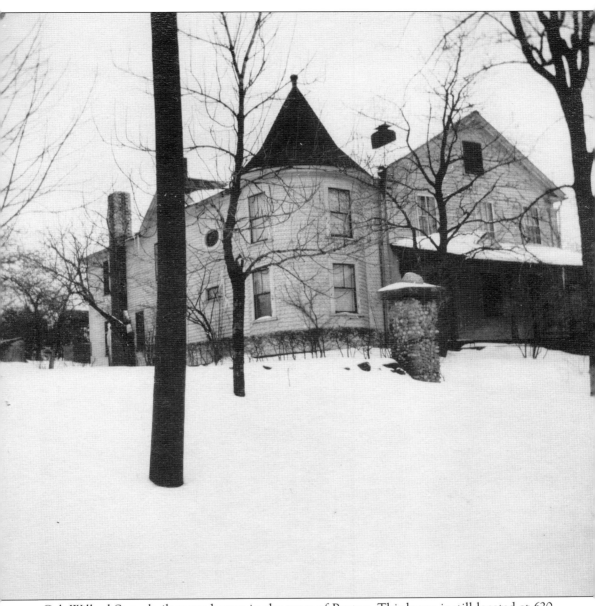

Col. Willard Snow built many homes in the town of Paxton. This home is still located at 620 Pleasant Street and maintains much of its original character. It was originally constructed for Ralph E. Bigelow, most likely between 1835 and 1846. Members of the Bigelow family were important figures in Paxton for many years. Ralph Bigelow was one of the owners of the large boot factory in town, first known as Bigelow & Lakin. After his partner, George S. Lakin, moved to Holden, it became Bigelow & Son. The boot industry thrived, and this company once employed approximately 500 workers, coming from Paxton and the surrounding towns. However, the end of the Civil War brought a marked decrease in the demand for boots, and this important town industry suffered and declined rapidly. Hon. Ledyard Bill purchased this home in 1898 after he married Sophia Earle, whose family lived next door. Prior to this, he had also lived in Louisville, Kentucky, and New York but often remarked that Paxton was "the dearest spot in the world."

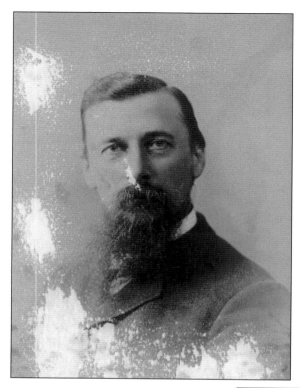

These two portraits show one of the town's most prominent citizens, Hon. Ledyard Bill. His unusual name came from being the first baby born in the newly formed town of Ledyard, Connecticut, after it separated from Groton. As an adult, he settled in Paxton and served as a state senator and held many town offices, including selectman, constable, overseer of the poor, cemetery trustee, and member of several boards. He also wrote several books, including *The History of Paxton*, published in 1889. He also donated the land for the town hall, which was dedicated on November 1, 1888, and gave the books that made up the first library in town.

After arriving in Paxton, Hon. Ledyard Bill married Sophia Earle, a young schoolteacher. These photographs are of their son Frederick Bill, who died in 1927. He is seen at right as a boy and below dressed for a part in a play. In the *Delta Upsilon Decennial Catalogue of 1903*, a fraternity publication, he is listed as having joined the fraternity while a student at Amherst College. His high school preparation was at Worcester Academy, which was founded in 1834 and only accepted males when Frederick attended. The fraternity catalogue also states that he went on to study at Harvard Law School. However, due to ill health, he was not able to complete his law studies.

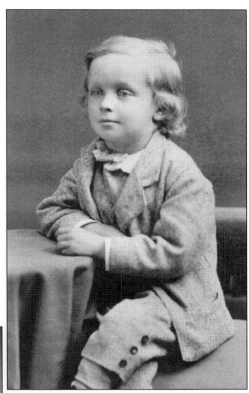

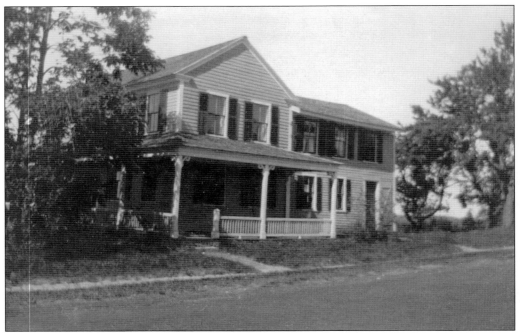

This two-story home above, which was owned by Luke Stratton, the village blacksmith, is one of the oldest dwellings in the town center, dating to the 1700s. It is still in its original location at 643 Pleasant Street. In the 1916 photograph below, a workman and a horse prepare to move a home from Richards Avenue to Maple Street. Homes at that time were often moved instead of being torn down.

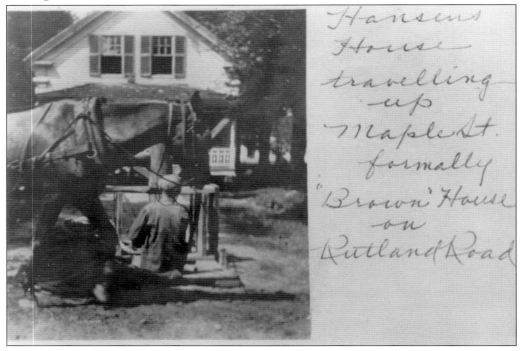

Hansens House travelling up Maple St. formally "Brown" House on Rutland Road

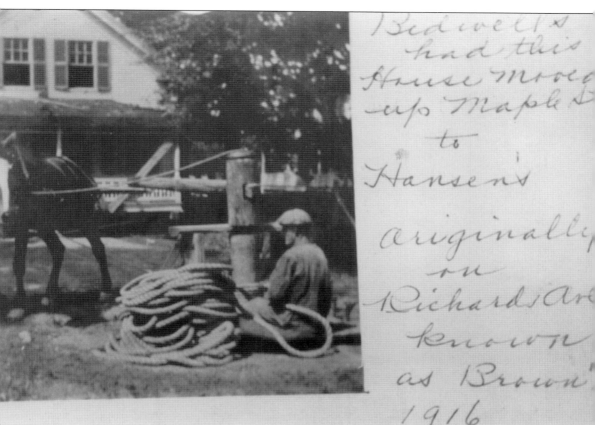

Bidwell's had this House moved up Maple t to Hansen's originally on Richards Av known as Brown' 1916

This photograph continues the chronicling of the moving of the home seen on the opposite page. It was taken by Etta Robinson, who noted that it was then known as "Hansen's House" but formerly had been known as "Brown's House." The process for moving the house was slow and laborious. First, the house would be jacked up off its foundations and placed on wooden beams. A wooden capstan was then placed ahead of the building, and, in this case, a single horse would begin winding a thick rope around the vertical shaft. Sometimes, a track made of wooden planks would be laid. Gradually, the house would be pulled on rollers as the horse walked around the capstan. Today, this house is still on this site, but it has had a dormer, an ell, and an enclosed porch added to the original portion of the house. On the eastern edge of this property, a stone wall marked the boundary between Leicester and Rutland before portions of both towns were incorporated to form Paxton in 1765.

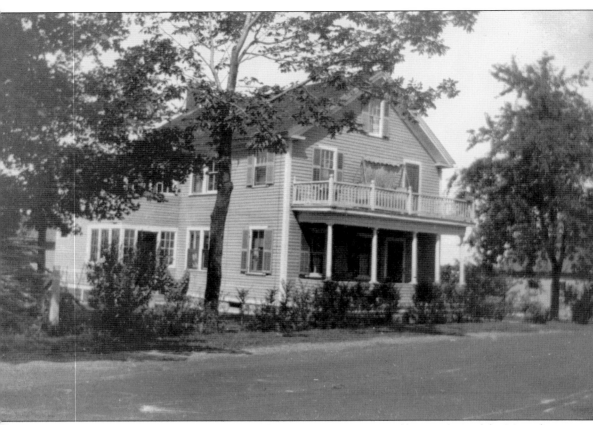

This home, next to the town hall at 699 Pleasant Street, was owned by members of the Maccabee family for over 100 years. It was originally the first Paxton Center School, on what was then School Street and is now Richards Avenue. It was purchased by Hon. Ledyard Bill in 1898, who converted it into a house. Note the Records Building to its right.

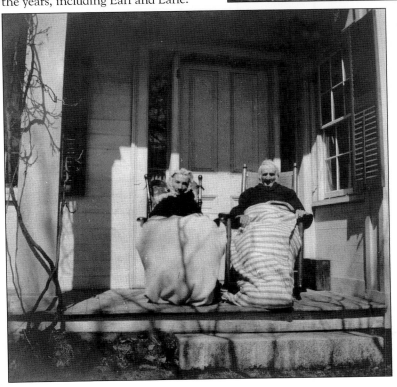

The home seen at right, at 624 Pleasant Street, belonged to Ralph Earle, a later descendant of Capt. Ralph Earl. It was built by him in 1840 and is seen here in 1910. Note the side gable, the steeply pitched roof, and the central chimney. Below, wrapped in blankets on the porch of the home, are Ralph Earle and his wife, Adeline Eulalia Bigelow Earle. Many family names used different spellings through the years, including Earl and Earle.

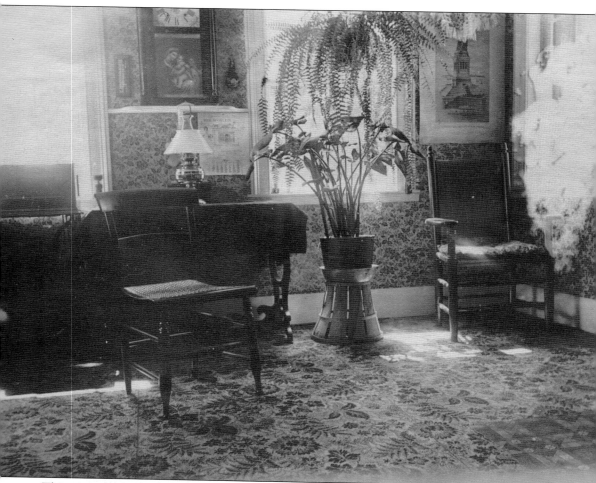

This view shows the living room of the Earle home at 624 Pleasant Street in the early 1900s. There is ample light coming in the large windows and an oil lamp on the table. Above the lamp is a clock featuring what appears to be a Renaissance copy of a painting of the Virgin Mary with an angel looking on.

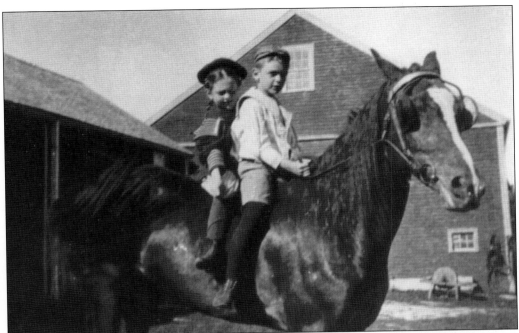

Horses remained important for work, transportation, and pleasure well into the 1900s. Above, a boy and a girl ride a horse without a saddle in front of a barn. Given the attention to their clothing, with dressy outfits and hats, it appears to be a posed scene. Below, on the same farm, a man drives a carriage in his Sunday best, with a similarly well-dressed woman behind him. The harness on the horse is a breast collar with a padded strap running around the chest from side to side, which was suitable for light work and transportation.

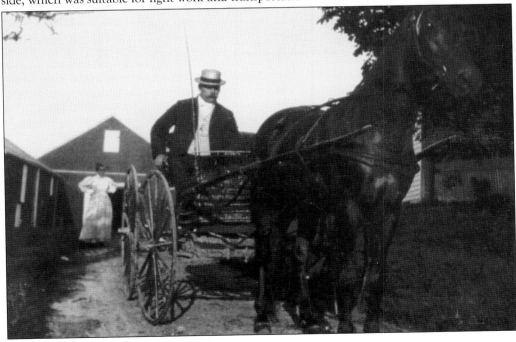

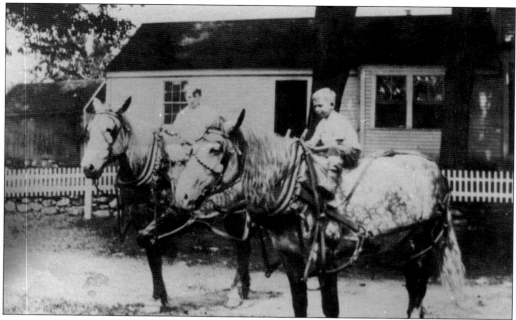

In the 1918 photograph above, the Eames boys ride workhorses without saddles in front of a home. Judging by the harnesses on the horses, they had likely recently finished some heavy work.

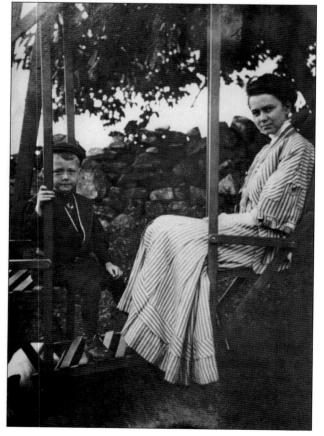

Myra Doane Everleth and her nephew Francis Lombard pose in fancy dress on a backyard swing. These popular garden swings provided secure seating for adults and children and smooth, comfortable movement.

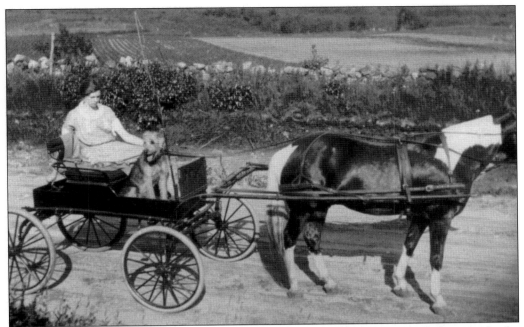

This young woman with her dog in an open Arabian horse-drawn carriage stopped to pose for the photographer. The well-defined, cultivated fields behind her illustrate the ongoing importance of agriculture in Paxton and the surrounding towns.

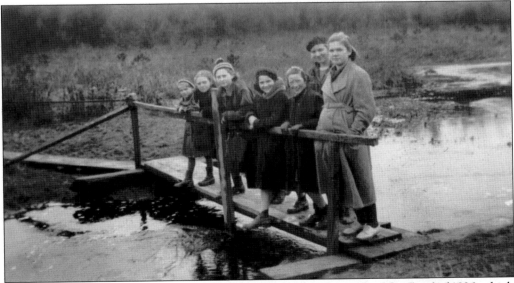

Several girls and women stand on a makeshift bridge in the aftermath of the flood of 1936, which affected the entire Northeast. Caused by a series of natural events, including heavy winter snowfall, sustained spring rains, and then ice dams, the flooding resulted in 10 deaths and left approximately 50,000 people homeless in Massachusetts. It also caused massive property damages. Although the areas near major rivers, such as the Connecticut River Valley in western Massachusetts, were hit particularly hard, Paxton also saw significant flooding.

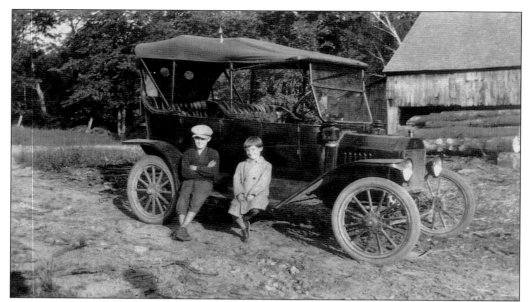

In this photograph from around 1925, George and John Knipe sit on the running board of a 1914 Ford Model T parked near the Eames sawmill, which is in the right background. The sawmill is now located in Moore State Park.

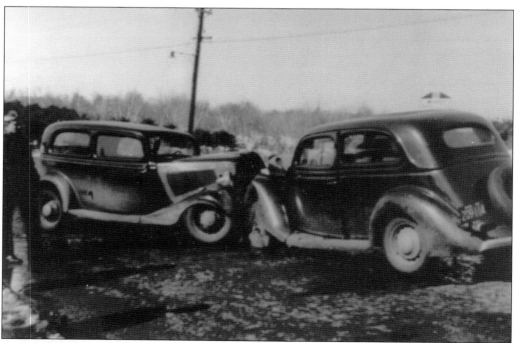

In the late 1800s, many experiments were made in attempts to produce a car, using steam, gasoline, and even electricity. However, it was Henry Ford's development of the mass production of the Model T that made it affordable to a large number of people. By 1920, cars were everywhere and accidents like this one were becoming common.

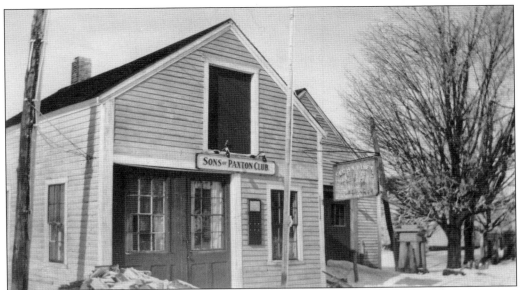

The sign on the left above clearly reads, "Sons of Paxton Club," and the older sign in the background advertises the Whitney blacksmith shop. This was the first meeting place of the Sons of Paxton, which was formed in 1922 for all young men over 18. Their baseball team is featured on the book cover. Note the entrance columns to the Paxton Inn in the right background. Later, the Sons of Paxton moved into their own building next door. Below, on the same site, Chester Everleth stands in front of the community store that replaced the blacksmith shop. Today, the building houses Paxton Liquors.

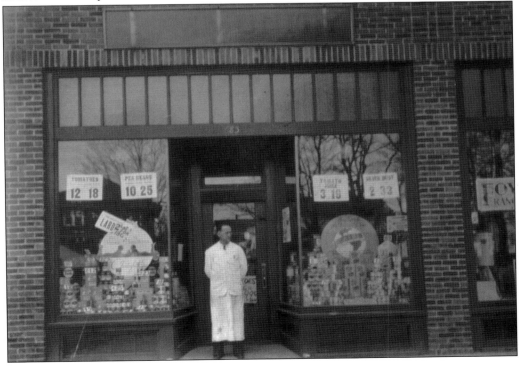

The image of Elizabeth Estabrook at left, dated 1857, reflects the American fascination with portraits in the mid-1800s. The subject was viewed frontally and posed from the waist up, likely in clothing especially chosen for the occasion. The note on the back of the photograph (below) indicates that Estabrook was the mother of Daniel, was 82 years old at the time of the sitting, and died that same year.

Viola Crouch (later Vi Crouch Prentice) is seen here during her high school years. The lifelong Paxton resident established the Paxton Center School library and went on to become the head librarian at Richards Memorial Library, championing its expansion in 1976.

As photography quickly developed, it became possible to have pictures taken by ordinary people instead of just by professional photographers. This popularization meant that individuals could capture formal as well as informal moments in their lives. Here, it is evident that it was important for the photographer to mark this gathering of family and friends.

Albert Crouch is seen here with his wife, Hattie Eames Crouch. For many years, beginning in 1912, the Crouch family owned the home at 14 West Street, near the center of town. It was built around 1830 by D. Russell Boynton with a substantial foundation of granite blocks and timbers more than one foot thick. Originally, all of the rooms had wide pine boards for flooring. Hattie was born in 1882 in the house at 11 Highland Street in Paxton. At the age of 93, when she was the oldest town resident, she contributed the history of that home to the publication *Paxton's Past Revisited*.

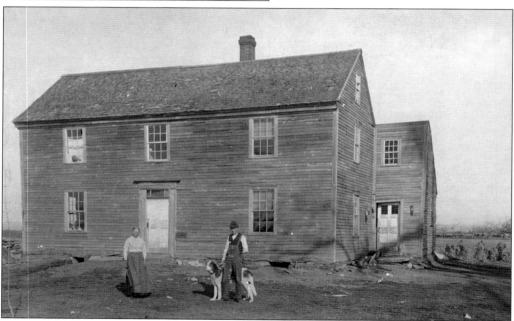

The vernacular style of architecture, seen in this home, developed from traditional British house types, which were used as models for early Colonial settlers. It has side gables and a symmetrical facade, with a central door leading to a hall with a staircase, flanked by a room on each side. The houses were usually one room deep, with a full second story and an ell typically added on later for the kitchen. This home belonged to members of the Lombard family, and in this 1895 photograph, Euclid and Mandy Lombard stand in front. Note the open fields in back of the home. Today, much of the area surrounding Paxton is second-growth forest, and there is much less open space.

Six

CELEBRATING, SERVING, AND PLAYING

The residents of Paxton have a long tradition of dedication to and celebration of their community. Celebrations of religious and civic events still maintain a prominent place in Paxton. On days like Memorial Day and the Fourth of July, there are parades, memorial speeches, and music as well as backyard barbecues where families and friends gather together. Through the years, the town has also sponsored events linked to the major religious holidays like Easter and Christmas as well as Halloween, with special events often planned for families.

Many organizations have formed over the years to serve the specific needs of the community. The earliest organization was the Female Reading and Charitable Society, which was founded in 1824 and reorganized as the Ladies Social Union in 1869. The women met each fortnight at each other's homes, where they would sew, discuss helping the church, and talk about their readings, which included religious poems, essays, and memoirs but not fiction.

Other groups included the Village Improvement Society, the Oraskasco Historical Society, the Grange, the Helping Hand Society, the Sons of Paxton, and others. All these groups focused on history, education, and the well being of town residents.

Paxton also celebrated its 100th, 150th, 200th, and 225th anniversaries in 1865, 1915, 1965, and 1990, respectively, as well as the nation's bicentennial in 1976. The town also celebrates Paxton Days each June. Town life is active and vibrant, focusing on revering its past, enjoying its present, and keeping hope in its future.

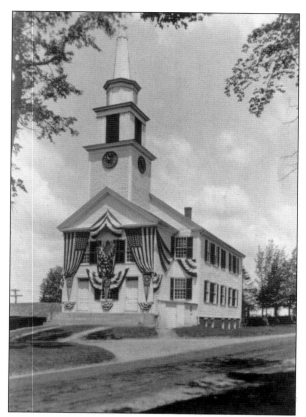

The book *One Hundred and Fiftieth Anniversary of the Town of Paxton, Massachusetts*, published by Davis Press in Worcester in 1917, provides an account of the 150th anniversary celebration, held on June 30, 1915. An estimated 2,000 to 3,000 people attended. The afternoon exercises were held in the First Congregational Church, which was decorated with bunting (left), as were most of the buildings in the town center. The interior (below) was also decorated in light blue and white, with palm leaves and gilt wreathes in the galleries and American flags draped over the rear of the platform and over a portrait of Charles Paxton, the town's namesake. In honor of Rev. William Phipps, the pastor from 1840 to 1869, his two sons, Rev. William Phipps Jr. and George G. Phipps, were in attendance. George Phipps, who composed the anniversary hymn, also read a poem he had written for the occasion.

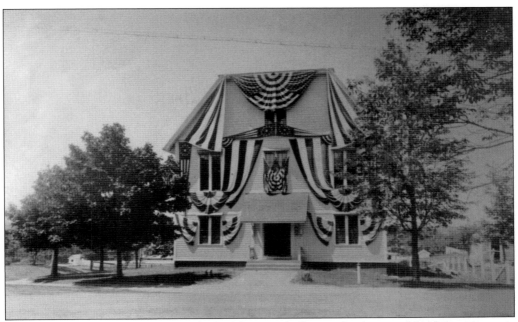

The exterior (above) and interior (below) of the town hall were also decorated for the anniversary. In February 1915, the committee of arrangements, appointed by the board of selectmen, met in the town hall. Herbert S. Robinson was the chairman, and Roxa Howard Bush was the secretary and treasurer. Other members included Henry H. Pike, Charles F. Flint, Henry C. Eames, Ellis G. Richards, William J. Woods, Henry L. Green, and Herbert W. Estabrook. The committee voted to hold the celebration on June 30, 1915, with the town contributing $400 for expenses related to the events. Later, a reception committee was also appointed as well as a parade committee of officers of the Grange, with Edwin F. Crouch as chairman.

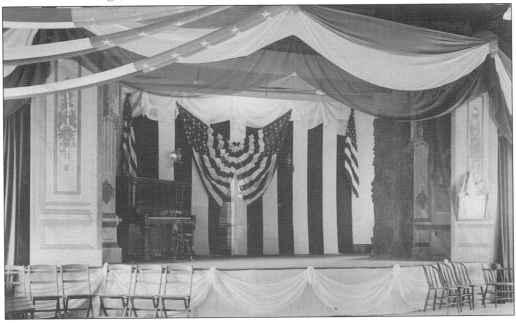

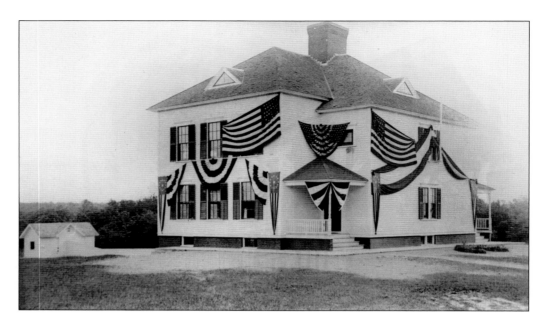

Other major buildings near the town center were also decorated in bunting for the 1915 anniversary celebration, including the Paxton Center School (above) and the Paxton Inn (below). An old tavern sign at the Paxton Inn showing Lord Charles Cornwallis and Charles Paxton shaking hands was hung from a flagpole. Written on the reverse side was the phrase, "Our good cheer makes enemies friends." Today, the message seems strange, as both Cornwallis and Paxton shared British loyalties. Cornwallis, fighting for the crown, surrendered to George Washington at the Battle of Yorktown in Virginia in 1781, and Charles Paxton made his final flight to England in 1776 with other loyalists.

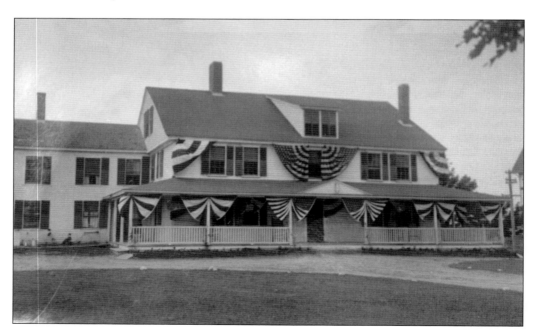

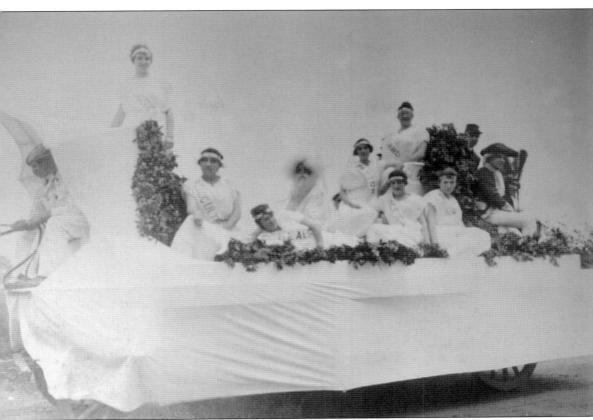

According to judges Walter E. Clark of West Boylston, David Davis of New York City, and Ernest C. Howard of Bellows Falls, Vermont, this float from Rutland was awarded first place in the 150th anniversary parade. Seen on the float are, in no particular order, Mabel R. Prescott, representing the town of Rutland, and Helen F. Rauser, Mary Rice, Alice F. Goldfinch, and Myrne L. Miles, representing the towns of Paxton, Barre, Hubbardston, and Princeton, which was once part of Rutland.

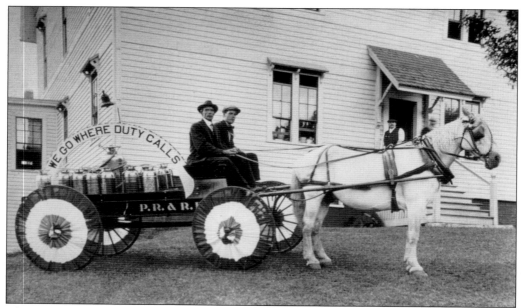

The Paxton Fire Department float is seen at the side of the town hall, under the charge of fire chief Arthur F. Stevens (left) and an unidentified man. The horse-drawn wagon was filled with handheld pump cans for fighting fires. Their motto was "We Go Where Duty Calls."

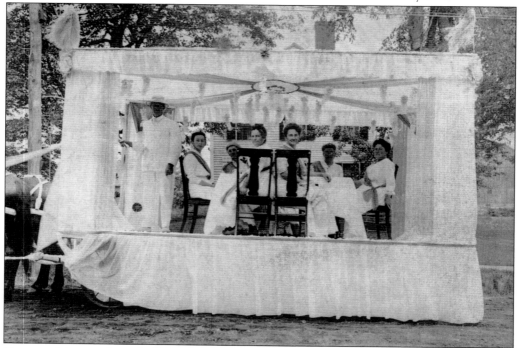

Decorated in purple and white, the Ladies' Social Union float represented a tearoom. The members were, in no particular order, Mrs. E.R. Lombard, Mrs. G.A. Rossier, Mrs. Lewis S. Clapp, Mrs. William L. Maccabee, Margaretta Catherwood, and Rena Robinson. Sumner Foskett (not pictured) was the driver.

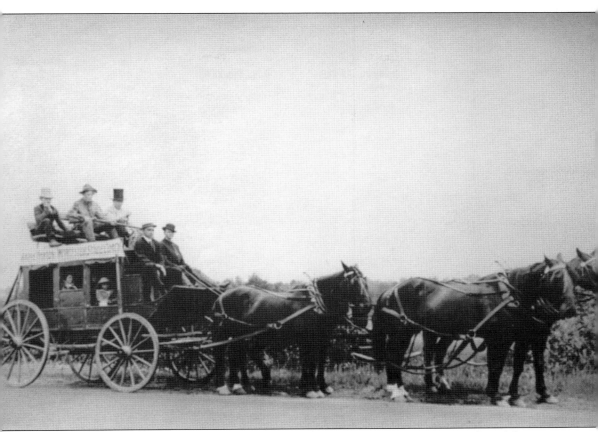

The Worcester-Paxton-Barre stagecoach is seen here with a full team of horses for the celebration in 1915. This popular form of travel stopped at the Paxton Inn. The boy in the window of the stage is Herbert Wentworth, who would later become a prominent person in Paxton.

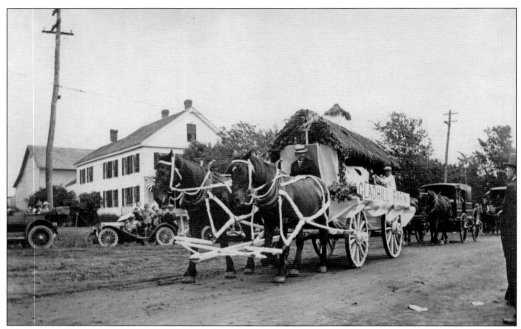

This line of carriages is headed by the float from Gladhill Farm. G.A. Rossier, the proprietor, was also the driver. The float represented a miniature barn. Inside were four young cattle, cared for by Frederick and Charles Stevens, Stuart Calderwood, and Francis Lombard. The lettering on either side of the wagon was made with milk-bottle caps.

For the 150th anniversary parade, individuals decorated carriages, wagons, and cars and proceeded to join the Paxton parade. This elaborately decorated carriage, complete with an umbrella to protect the driver from the sun, is hitched up and ready to go. The Paxton Driving Club offered a silver cup as an award for the best-decorated vehicle.

A young Viola Crouch (later Vi Crouch Prentice) is seen here riding in a decorated stroller complete with the American flag during the 1916 Fourth of July parade.

The 1960 Fourth of July parade is seen here, with a marching band traveling down Richards Avenue led by the majorette in front. The First Congregational Church is in the left background, and the town common is in front of it.

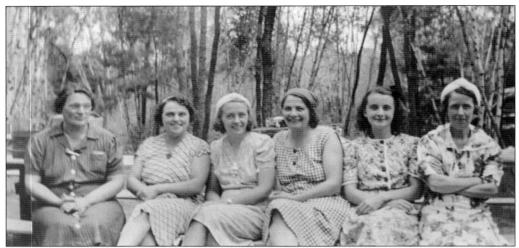

The residents of Paxton like to celebrate, especially in warmer weather, when everyone can enjoy the rural setting of the town. The celebrations are often highlighted by parades, picnics, and barbecues. The writing on the back of this photograph states that it was taken at an American Legion barbecue. Paxton American Legion Post 306 was established in 1958 as a private corporation and maintains its offices at 885 Pleasant Street.

Paxton Days is celebrated every June, usually on the third weekend. In this photograph by Jerry Ryan, the current director of the Paxton Council on Aging, the celebrations are centered near the Civil War monument, in front of the peaked tent. On the right is St. Columba's Catholic Church. Due to the expansion of the celebrations, Paxton Days has recently moved to the Wentworth Field near Paxton Elementary School on West Street, near the town center. It remains a popular event with a wide range of activities, including vendors in booths selling a range of goods, food, and drinks, games for the family like sack races and a pie-eating contest, an auto show, and art contest sponsored by the Paxton Historical Commission, and a bike safety event sponsored by the police department with free helmets for children who complete the program. (Courtesy of Jerry Ryan and the Paxton Historical Commission.)

Paxton marked its bicentennial on February 12, 1965, with a series of celebratory events, including a bicentennial ball held on the evening of February 12 and a bicentennial breakfast following a worship service on February 14. A traditional parade was held once the weather was warmer. The bicentennial ball was held in the Paxton Center School auditorium, which was decorated with balloons and crepe-paper streamers. Couples are seen above marching, as others view the activities from chairs on the raised area on the right. Below is a copy of a ticket to the ball, advertising Ray Morton's orchestra. Tickets were $2.

Paxton Bi-Centennial Ball

Paxton Center School Gym
February 12, 1965

Ray Morton's Orchestra

Dancing: 9 - 1: o'clock
Refreshments

Dress: Costume or Semi - formal

Ticket: $2.00

Above, announcements and thanks are given at the bicentennial ball and the stage is set up with band instruments for music and dancing. Most of the women are in costumes modeled after Colonial patterns, while most of the men are in suits and ties or tuxedos. On the wall is the official town seal, with the image of the First Congregational Church and the dates 1765 and 1965. Mrs. Leonard W. Morrison was the chair of the bicentennial ball, and Mrs. Donald E. Norton was chosen as bicentennial queen. Below, couples march in a double-line formation.

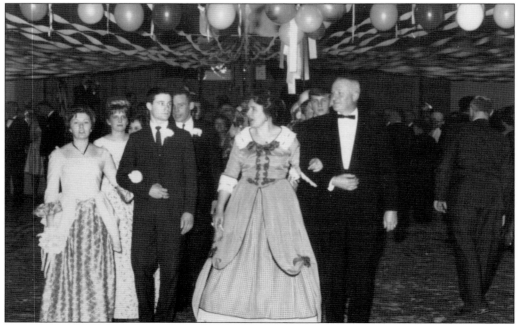

The First Congregational Church is seen at right decorated in red, white, and blue bunting for the town's bicentennial parade in 1965. Below, the Paxton Inn is also decorated with bunting, and an antique car is parked in front of the inn and ready for the parade. Both of these buildings featured prominently in the bicentennial breakfast activities held earlier that year on February 14, 1965. The day began with services at the First Congregational Church, led by Rev. Oscar E. Remick, and at St. Columba's Catholic Church, led by Rev. Harold F. Griffin. Following the services, there was a bicentennial breakfast at the Paxton Inn.

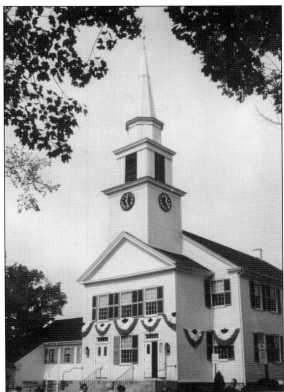

This building along the parade route on Pleasant Street was decorated with bunting and had the American flag flying high. The building was the clubhouse for the Sons of Paxton. The building is now adjacent to Paxton Liquors and currently houses Theo's Breakfast and Lunch, previously Coffee on the Common.

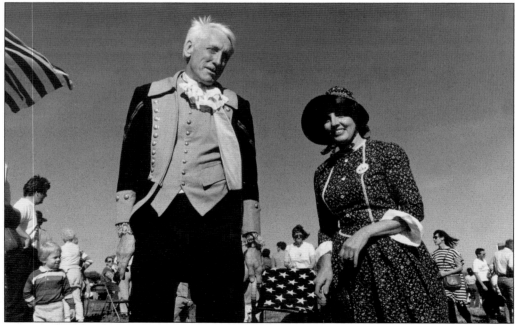

Continuing its well-established tradition of celebrating its milestone anniversaries, Paxton hosted activities for its 225th anniversary in 1990. Here, a man and a woman carefully dressed in Colonial garb mingle with those in contemporary clothing during the celebrations.

Above, Etta Eames Robinson, the town's oldest resident, waves at the crowds lining the streets to celebrate the 225th anniversary of Paxton. She died in 1994, one month from her 100th birthday.

Etta Eames Robinson posed for this formal portrait when she was in high school. She stands in a lovely dress, wearing a bow in her hair and holding onto a chair in front of her.

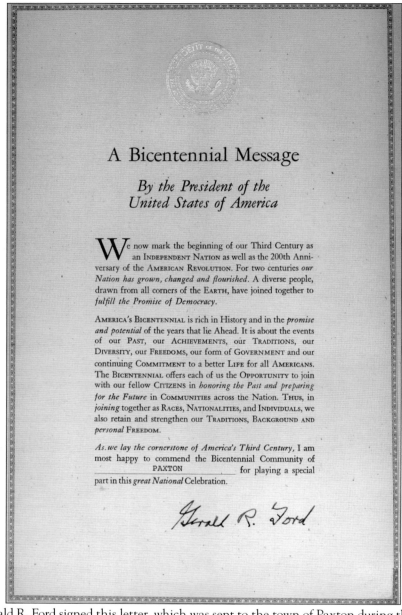

A Bicentennial Message

By the President of the United States of America

We now mark the beginning of our Third Century as an INDEPENDENT NATION as well as the 200th Anniversary of the AMERICAN REVOLUTION. For two centuries *our Nation has grown, changed and flourished*. A diverse people, drawn from all corners of the EARTH, have joined together to *fulfill the Promise of Democracy*.

AMERICA'S BICENTENNIAL is rich in History and in the *promise and potential* of the years that lie Ahead. It is about the events of our PAST, our ACHIEVEMENTS, our TRADITIONS, our DIVERSITY, our FREEDOMS, our form of GOVERNMENT and our continuing COMMITMENT to a better LIFE for all AMERICANS. The BICENTENNIAL offers each of us the OPPORTUNITY to join with our fellow CITIZENS in *honoring the Past and preparing for the Future* in COMMUNITIES across the Nation. THUS, in *joining* together as RACES, NATIONALITIES, and INDIVIDUALS, we also retain and strengthen our TRADITIONS, BACKGROUND AND *personal* FREEDOM.

As we lay the cornerstone of America's Third Century, I am most happy to commend the Bicentennial Community of _____PAXTON_____ for playing a special part in this *great National* Celebration.

Gerald R. Ford

Pres. Gerald R. Ford signed this letter, which was sent to the town of Paxton during the nation's bicentennial celebration in 1976. Given the history of the town and the commitment of many of its men and women to the American Revolution, it was particularly meaningful to honor this date. In *The History of Paxton*, Hon. Ledyard Bill recounted the story of Jason Livermore, who was working in the fields with his three sons when the call to arms came. He reportedly said, "Boys, unyoke the cattle and let us be off," and they then melted down the household silver to make bullets. Livermore's wife, Abigail, was left at home to farm and care for the stock with their 12-year-old son. She also completed the laborious process of making 100 pounds of saltpeter, which was needed for gunpowder. President Ford commended the community for the role it played in the celebratory event.

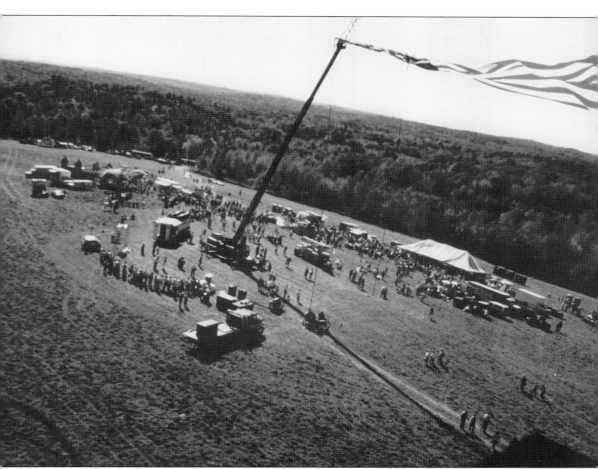

This aerial perspective provides an excellent view of the enormous Mount Rushmore flag raised for the 225th anniversary of the incorporation of Paxton in 1990. The complex set up for this event is seen, including the mechanism for raising the flag and the specialized flagpole as well as many of the people who participated in the raising of the flag.

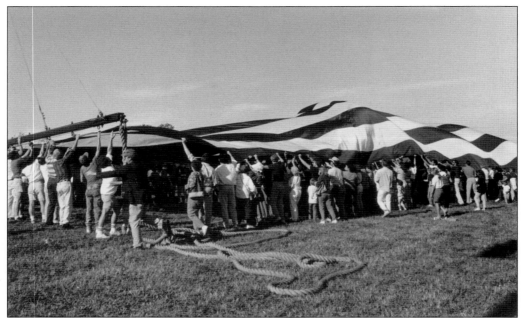

Approximately 400 people were needed to assist in raising the enormous Mount Rushmore flag for the 225th celebration of the incorporation of Paxton in 1990. The complicated process required teamwork. The photograph above shows the beginning of the process, as everyone spreads out and holds the edges of the flag to keep it off the ground, out of respect for the flag and to ready it to be raised. Below, the flag is beginning to rise upward. The man near the center in the dark jacket is controlling the speed, gradually feeding the thick, long rope that is coiled beneath his feet as the flag moves higher.

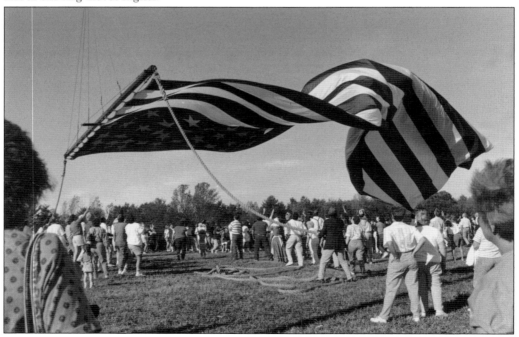

As the sun began to set, the Mount Rushmore flag appeared translucent in the dimming light. This photograph provides a good view of the specialized flagpole and roping used to raise and fly the flag. Mount Rushmore flags have been raised in communities across the United States, often on the Fourth of July or on significant dates in a town's history.

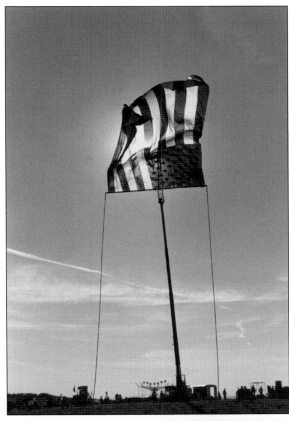

Edward Duane, a dynamic contributor to the Paxton Historical Commission and an expert on cemeteries and gravestone rubbings, identified seven minutemen from the American Revolution buried in the early cemetery next to First Congregational Church. He is seen below in the center left talking about what can be learned from a visit to the cemetery, including information about economic, social, and religious changes and the effects of wars and epidemics.

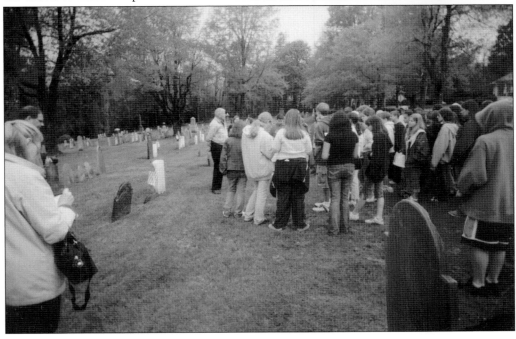

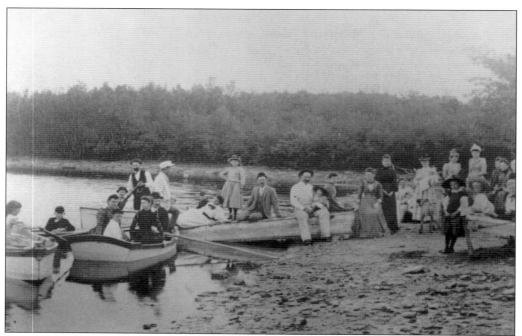

Set in the hills of central Massachusetts, Paxton is an important watershed area and has four streams flowing into three drainage areas, including the Nashua River, flowing north; the Chicopee River, flowing west; and the Blackstone River, flowing south. In the early photograph above, a large group of men, women, and children are on the shore or in small boats pulled up to the shore. They are well dressed and likely there for a special outing. Below, two men fish from the shore. The hotels in Paxton in the late 1800s and early 1900s advertised outdoor activities such as these as being available for visitors. While there are also numerous ponds in the area, most have become reservoirs and are no longer available for recreational use.

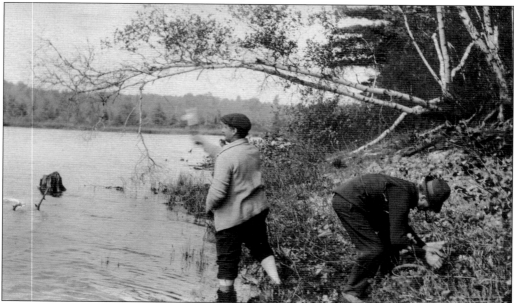

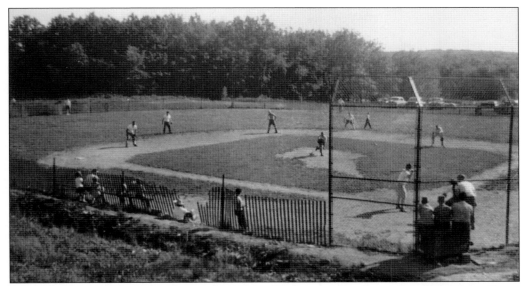

Baseball, the quintessential American pastime, has been enjoyed greatly by Paxton residents through the years. This game is being played at the field near the Paxton Center School, on land that was formerly the Illig farm. The Sons of Paxton baseball team also played here. These fields are still in use, and soccer fields have more recently been constructed on the former Klingele land on Grove Street.

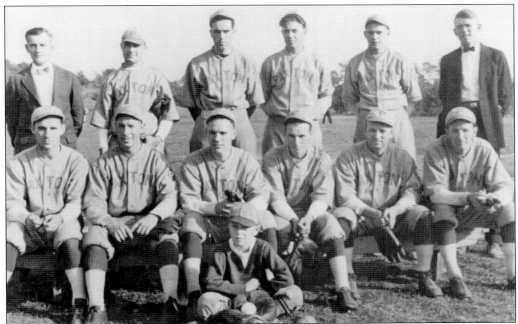

Pictured here are the Sons of Paxton baseball team. From left to right are (first row) mascot Danny Woodbury; (second row) Walter Hughes, SS; Wesley Ferry, IF; Archie Hughes, 2B; Samuel Knipe, captain and CF; George Maccabee, CF; and Robert Catherwood, RF; (third row) Daniel Woodbury, manager; Lawrence Girouard, 3B; George Bradshaw, P; Gaylord Pike, 1B; Walter Pike; and Richard Catherwood, official scorer.

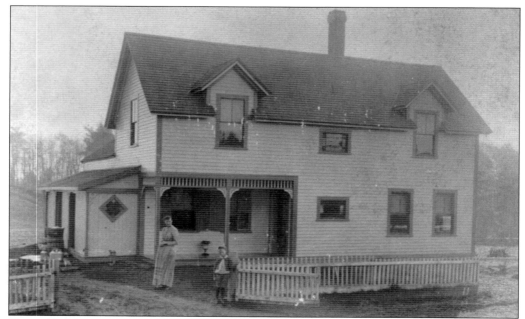

Henry H. Pike, seen here as a young boy in front of his home at 306 Grove Street, grew up to be a prominent resident, serving in many town offices, including as a selectman and as road commissioner. The home, built around 1800, was purchased by the Pike family around 1890 and remained in the family until 1930. The site was also the entrance to Camp Pike, which Roxa Howard Bush described thusly in her 1923 book *Landmarks and Memories of Paxton*: "A dozen and a half cottages overlooked Asnebumskit Pond. Horace Pike bought the camp property from his brother, Henry."

Camp Pike was a popular area, especially in the summers, for recreation and enjoying the cooler weather in the hills of Paxton. This postcard shows the opposite side of Asnebumskit Pond. Cottages line the hillside on the far side of the pond. The cottages were actively used in the early 1900s. The residents of Camp Pike had a sense of community; for the 150th anniversary of the town in 1915, they entered decorated automobiles in the parade competition. Other similar areas such as Camp Rita also participated.

In 1953, the newly established Paxton Recreation Commission opened a sandy-bottomed swimming pool, which was called the Herbert Wentworth Memorial Swimming Facility to honor Wentworth and his service to the town. The scale of the one-acre pool is evident in the photograph above. The wooden dock that was installed at the original pool is seen below in the foreground, with a number of people on it. The pool, upgraded in 1964 and again in 1986, provided a place for swimming and lessons for more than 45 years. It was eventually removed, but it is remembered fondly by several generations of Paxtonites.

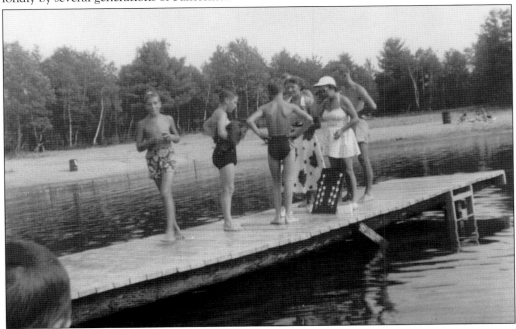

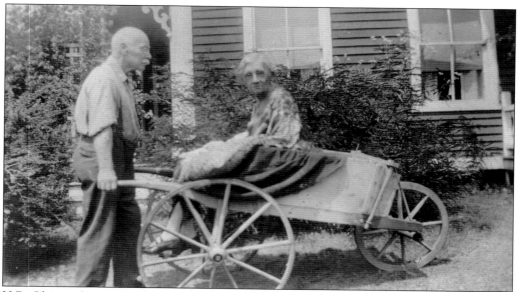

H.B. Olmstead ran a blacksmith and wheelwright shop and reportedly also had a sawmill in Paxton. In this 1931 photograph, he pushes a wooden wheelbarrow, giving Rena Robinson, sitting in the wheelbarrow, a ride home.

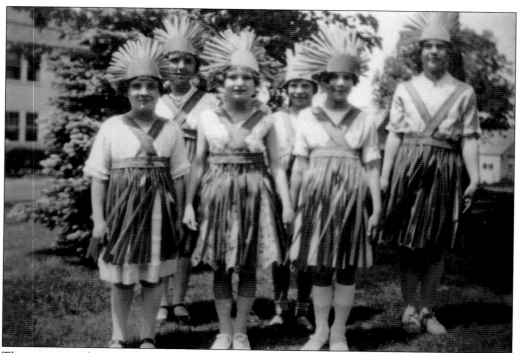

These young girls appear to be part of a celebration, as all six of them are wearing similar outfits of white blouses, knee socks, skirts that are overlaid with apron-like materials, and headdresses.

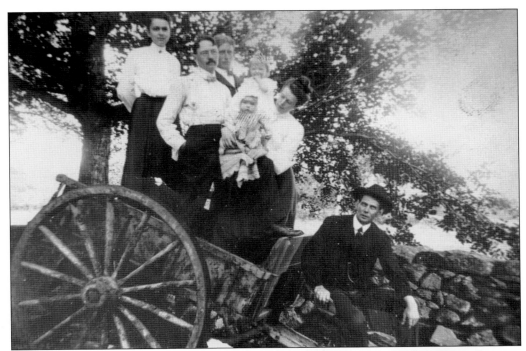

In this agricultural community, wagons figured prominently in everyday life. In the historical photograph above, however, the wagon is not being used for practical purposes. Myra Doane Everleth (top of wagon) joins others in their Sunday best, posing for a photograph in a tilted wagon, with the backdrop of a tree and a stone wall. In this photograph at right, Lou Brouillard (right) gets ready to board an American Airlines plane. Born Lucien Pierre Brouillard in 1911 in Quebec, Canada, he lived for a time in Paxton at 442 Marshall Street and also on Pleasant Street. He was the World Welterweight Champion from 1931 to 1932 and World Middleweight Champion in 1933. He died in 1984. In 2006, he was inducted into the International Boxing Hall of Fame.

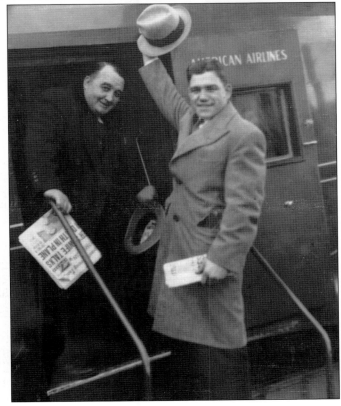

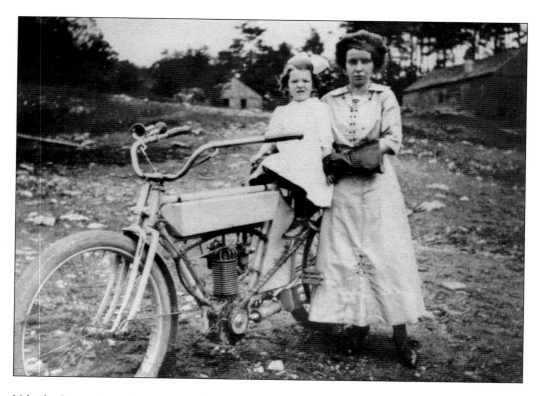

Vehicles have always been used for fun as well as necessity. In the early 1900s, many more types of vehicles became available to a larger number of people. Above, the Eames' daughters pose at the sawmill with an early motorbike. Below, Viola "Vi" Crouch and Vernon Prentice pose on the running board of a car. They were later married.

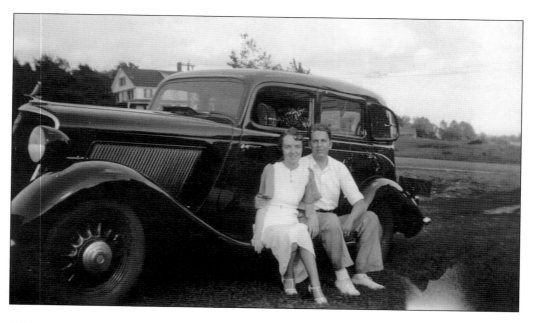

Seven

Moore State Park and Land Preservation

Paxton is fortunate to have large expanses of land that are protected for future generations. The best-known site is Moore State Park, named for Maj. Willard Moore, who died at the Battle of Bunker Hill on June 17, 1775. Currently administered by the Massachusetts Department of Conservation and Recreation, it was purchased by the Commonwealth of Massachusetts in 1965 from the Spaulding family of Worcester. Connie Spaulding, who belonged to the Worcester Garden Club and the Massachusetts Horticultural Society, supervised the planting of many of the azaleas and rhododendrons that offer spectacular spring blooms. With a reconstructed mill and early foundation stones along the dramatic 90-foot drop of Turkey Hill Brook, the scenery draws many visitors. Today, Moore State Park encompasses approximately 725 acres and has been added to the National Register of Historic Places as a historic landscape.

The town and local organizations continue to maintain a commitment to preserving the landscape for the protection of the watershed, wildlife, and passive recreational activities. The availability of large farms facilitated conservation efforts. In 1899, Charles D. Boynton willed Boynton Park to the City of Worcester for the enjoyment of the residents of Worcester and Paxton. Efforts by the City of Worcester and Paxton protect area reservoirs and tributary streams and, thus, the water supply. The Massachusetts Division of Fish and Game also set aside the 262-acre Moose Hill Wildlife Management Area for seasonal hunting.

Recent collaborations between state, local, and nonprofit organizations resulted in the preservation of 56 acres at Muir Meadows, protecting the watershed of Southwick Pond and creating a hiking corridor from Leicester through Paxton to Boynton Park. Lastly, more than 1,600 acres in the area have been placed in Massachusetts Chapter 61 protection for agricultural or forest use. Since 1996, the Paxton Land Trust has also worked towards preserving open spaces to ensure a high quality of life for present and future generations.

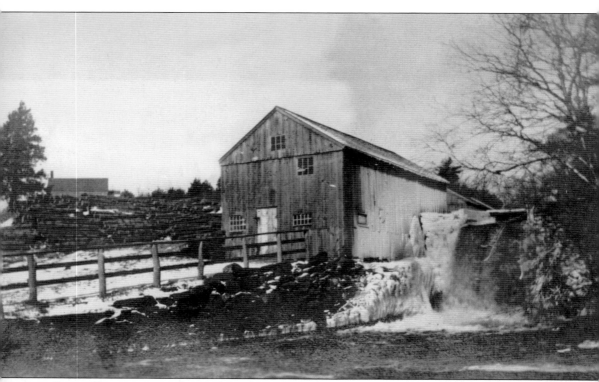

Gristmills were a critical part of the successful survival and growth of agricultural communities. In the 1700s, agriculture was the main focus of American life and work. In order for a gristmill to function, it needed waterpower. Therefore, the site at Turkey Hill Brook was ideal because of its 90-foot drop, which provided the power needed to run the mill. Farmers transported their grain and corn to the gristmill, where it was ground up into flour for use in food production for individuals and for sale. At the gristmill, the pit wheel was connected to the main water mill, which turned the millstone, crushing the grain and corn on the bed of stone. This gristmill is no longer standing, but it was part of the original settlement in the mid-1700s. The site is now part of Moore State Park.

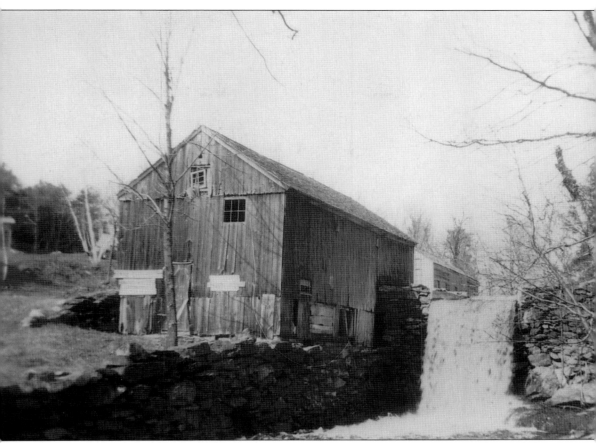

The steep drop of 90 feet at Turkey Hill Brook attracted both gristmills and sawmills, and the area became known as the Newton sawmill village. The area is now part of Moore State Park, and archaeological excavations have unearthed some of the original foundations of the mills and early settlement. While the water was a boon for powering the mill, the water level varied at different times of the year. In the spring, with snow melt and spring rains, the surge of water could be dangerous and destructive, eroding the stonework and even threatening the mill itself if flooding occurred. Therefore, it was necessary to inspect and repair the mill structure and the stonework, especially after the spring rains. This image and the one on the following page provide closer views of the mill and the stonework.

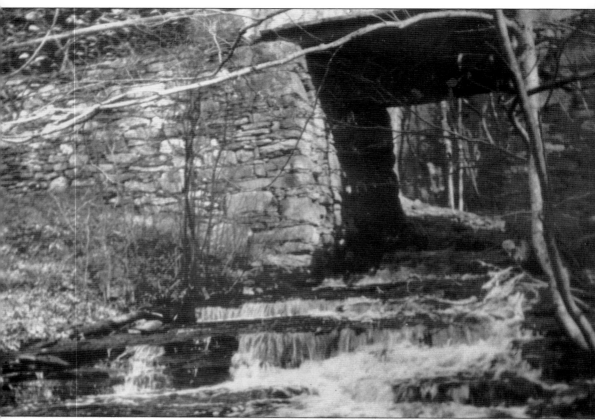

This photograph is a close-up of the stonework at the sawmill. The stones for the foundation of the mill were dry-laid, meaning that there was no material used as mortar between the stones. The rocky New England countryside provided the natural material needed. Stones that interfered with plowing were continually removed from fields, hence the frequency of the picturesque and ubiquitous stonewalls in the countryside. Stones were also a useful building material, and they were sorted according to size, with the largest laid at the bottom and the smaller ones used for chinking, or filling in, the small voids between stones. While it looks simple, building a sturdy dry wall took patience and extensive skill. It was also necessary to continually check the integrity of the stonework due to erosion from water, wind, and weather. Any weak areas needed to be repaired immediately or they could eventually weaken the entire foundation.

The sawmill on the site of Moore State Park is usually dated to 1747, well before the town of Paxton was carved out of the neighboring towns of Leicester and Rutland. Lumbering was critical for transforming the many trees cut down for agriculture into useful boards for building homes and other buildings. Paxton had a marked increase in the sawing of lumber and firewood between 1830 and 1870. As the neighboring city of Worcester expanded, Paxton provided a portion of the much-needed lumber for building and firewood for fuel. In 1845, Paxton produced 121,000 feet of lumber, a number that increased to more than 600,000 feet by 1865. During this period, the number of cords of firewood ranged from 1,300 to 1,800. While this provided a boost to the Paxton economy, it also denuded the terrain of old-growth timber.

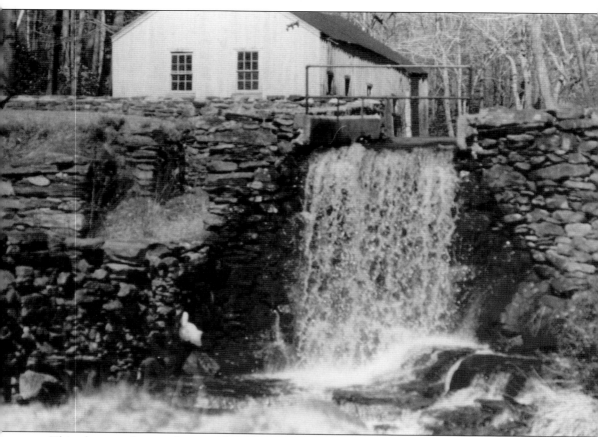

This photograph provides a good view of the waterfall that was used as a power source and the stone walls on either side. The active mills in the area required many people to work in the mills and to provide the necessary support to keep the mills functioning. Given the ongoing activity at the gristmill and the sawmill, there was also considerable demand for tools and components of wrought iron. Blacksmiths were essential for maintaining its functioning, as well as for properly shoeing the horses that hauled heavy wagonloads of trees, finished lumber, firewood, and sacks of grain, corn, and flour. The ownership of the mill village changed hands several times, but it was eventually bought by the Commonwealth of Massachusetts in 1965 for inclusion in the state park system.

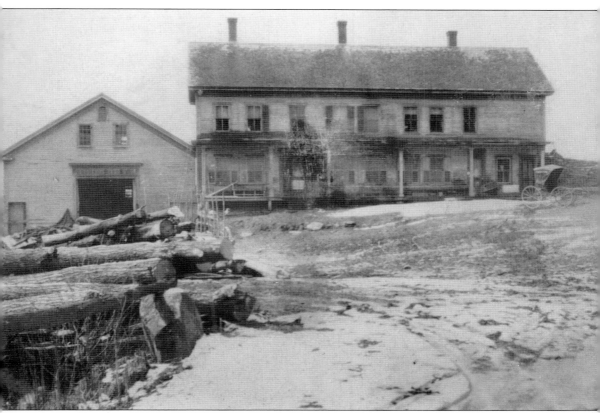

This home was reportedly built by William Cumins, who purchased the mill sites and the surrounding land in 1864. Later, this house and the mills came into the possession of Edward Eames. The barn is also seen here to the left. While the home was two and a half stories and had 22 rooms, it was divided down the middle to provide workers with a place to live in the 11 rooms at one end. The home was destroyed by fire on February 23, 1917, and was not rebuilt. Visitors can still see some of the remains of the foundation of the expansive home and barn.

Edward Eames owned the 22-room house, barn, and mill in what is now Moore State Park. He is seen here in this formal photograph taken in a portrait studio.

Given the high elevation of the town of Paxton, with Asnebumskit Hill rising to almost 1,400 feet above sea level, the town often experiences snow when Worcester only gets rain. This photograph shows the aftermath of the December 2008 ice storm, with tree limbs laden down with heavy ice. The major storm hit New England and parts of New York. In Massachusetts, it was estimated that more than one million residents and businesses were without electric power for extended periods of time because of the storm. Paxton was hit hard, and there were significant losses of power because of trees and tree limbs that fell on utility lines and knocked down poles. Gov. Deval Patrick declared a state of emergency in Massachusetts. Limbs continued to break off for days afterward because of the weight of the thick ice, and residents described the sounds as seeming like gunshots continually going off in the woods. (Courtesy of Cathy Friedman and the Paxton Historical Commission.)

This post-and-beam bridge is a more recent addition to the grounds of Moore State Park. It was built in 1998 as a tribute to Judy Russell, a Paxton artist and teacher who was instrumental in establishing Moore State Park as a peaceful sanctuary in which to enjoy nature. She fostered the care and maintenance of this precious historical landscape. The bridge was given the name Enchanta after the name Connie Spaulding had given the property. Upon first seeing it, the story goes, Spaulding was sure that it was so beautiful that it must be enchanted. The entire site is listed in the National Register of Historic Places and cited for its historical significance in commerce, settlement, industry, and agriculture and its connection to earlier cultural affiliations with the Nipmucks and early European settlement. Paxton residents are fortunate to be able to explore the area's early history at the Newton sawmill village site, which has been so well preserved by former caretaker Denis Melican and the Massachusetts Department of Conservation and Recreation.

BIBLIOGRAPHY

Bill, Ledyard. *The History of Paxton, Massachusetts.* Worcester, MA: Putnam, Davis and Company, 1889.

Brodeur, David, D. "Evolution of the New England Town Common: 1630–1966." *The Professional Geographer* XIX, No. 6 (November 1967): 313–318.

Bush, Roxa Howard. *Landmarks and Memories of Paxton.* Paxton, MA: self-published, 1923.

E. Alfred Jones. *Loyalists of Massachusetts.* London: Saint Catherine Press, 1930.

Mandell, Daniel R. *Tribe, Race, History: Native Americans in South New England, 1780–1880.* Annapolis, MD: John Hopkins University Press.

Massachusetts Historical Commission Reconnaissance Survey Town Report – Paxton. Boston: Massachusetts Historical Commission, 1984.

Membrino, Marcia L., and Paul A. Russell, eds. *Paxton, Massachusetts – Births, Marriages and Deaths 1748–1850.* Bowie, MD: Heritage Books, 1996.

Miller, Lillian B. *In the Minds and Hearts of the People: Prologue to the American Revolution, 1760–1774.* Greenwich, CT: New York Graphic Society, 1974.

Nason, Rev. Elias, revised by George J. Varney. *Gazetteer of the State of Massachusetts.* Boston: B.B. Russel, 1890.

Paxton Historical Commission. *Our Town Program Audio Journal.* Paxton, MA: 2011.

Phipps, William. *A discourse, delivered in Paxton, Mass., on the day of the annual state of Thanksgiving, November 24, 1864.* Worcester, MA: Adams & Brown, 1864.

Soderman, Doris Flodin. *The Sculptors O'Connor.* Worcester, MA: Gundi Publishers, 1995.

Stickney, Edward and Evelyn. *The Bells of Paul Revere: His Sons and Grandsons.* Bedford, MA: 1976.

Taronas, Katherine M., and Laura E. Then & Now: *Paxton.* Charleston, SC: Arcadia Publishing, 2008.

Williams, John. *The Redeemed Captive, Returning to Zion.* Third Edition. Northampton, MA: Hopkins, Bridgman & Company, 1853.

DISCOVER THOUSANDS OF LOCAL HISTORY BOOKS
FEATURING MILLIONS OF VINTAGE IMAGES

Arcadia Publishing, the leading local history publisher in the United States, is committed to making history accessible and meaningful through publishing books that celebrate and preserve the heritage of America's people and places.

Find more books like this at
www.arcadiapublishing.com

Search for your hometown history, your old stomping grounds, and even your favorite sports team.

Consistent with our mission to preserve history on a local level, this book was printed in South Carolina on American-made paper and manufactured entirely in the United States. Products carrying the accredited Forest Stewardship Council (FSC) label are printed on 100 percent FSC-certified paper.

MADE IN THE
USA